Paint Lab

Paint Lab

52 Exercises Inspired by Artists, Materials, Time, Place, and Method

Deborah Forman

Quarry Books
100 Cummings Center, Suite 406L
Beverly, MA 01915

quarrybooks.com • craftside.typepad.com

© 2013 by Quarry Books

First published in the United States of America in 2013 by
Quarry Books, a member of
Quayside Publishing Group
100 Cummings Center
Suite 406-L
Beverly, Massachusetts 01915-6101
Telephone: (978) 282-9590
Fax: (978) 283-2742
www.quarrybooks.com
Visit www.Craftside.Typepad.com for a behind-the-scenes peek at our crafty world!
Visit www.QuarrySPOON.com and help us celebrate food and culture one spoonful at a time!

10 9 8 7 6 5 4 3 2 1

ISBN: 978-1-59253-782-2

Digital edition published in 2013
eISBN: 978-1-61058-947-5

Library of Congress Cataloging-in-Publication Data

Forman, Deborah.
 Paint lab : 52 exercises inspired by artists, materials, time, place, and method / Deborah Forman.
 pages cm
 Summary: "Paint Lab is packed with unique and experimental techniques and ideas in painting. This hands-
on book is organized into 52 units, which may, but don't need to be explored on a weekly basis. The labs can
be worked on in any order, so that you can flip around to learn a new mixed-media technique or be inspired
by a particular painting theme or application. The underlying message of this book is that, as an artist, you
should learn and gain expertise through experimentation and play. Paint Lab is illustrated with brilliant full-
color images and multiple examples of each exercise. This book offers you a visual, non-linear approach to
learning painting techniques, and reinforces a fun and fearless approach to creating art." —Provided by
publisher.
 ISBN 978-1-59253-782-2 (pbk.)
 1. Painting--Technique. I. Title.
 ND1473.F67 2013
 751--dc23
 2013012479

Book layout: *tabula rasa* graphic design, www.trgraphicdesign.com
Series design: John Hall Design Group, www.johnhalldesign.com
All artwork by Deborah Forman, unless otherwise noted.
Developmental editor: Marla Stefanelli

Printed in China

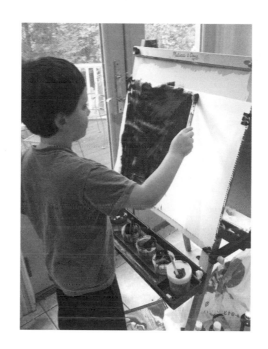

For Nathaniel, with love

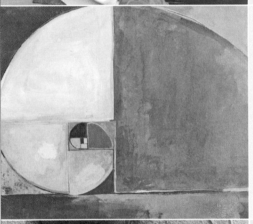

Contents

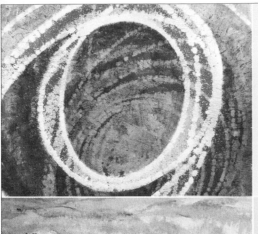

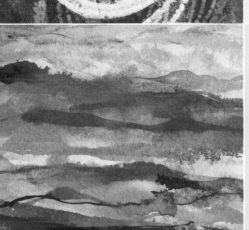

Introduction

I WAS WATCHING my five-year-old son the other day at the painting easel in our kitchen. I observed his enjoyment in the texture of the materials, and an uninhibited excitement about touching the paint to the surface of the paper. I imagine his inner dialogue went something like this: "How can I make the tempera flow? What happens if I mix these colors? What happens if I use the brush like this, or make marks like this?" Most likely, though, there was no dialogue at all, as he was truly spontaneous in his actions. There is a lot to learn from this. Painting harnesses the fun of play. Play is crucial to the creative process because a by-product of play is pleasure. I believe that the underlying principle of pleasure should always be present in the painting process. Play also brings you to the present moment. In this age of disconnect due to the prevalence of technology and screen time, painting can be an antidote as it connects you to your surroundings with the physical world.

Painting brings you to the present moment. Painting activates your physical sense of self. Painting helps you to feel alive and connected!

Many of the projects are based on experimenting with varying materials, surfaces, and concepts. Years ago I read an article about the work habits of well-known geniuses such as Picasso, Einstein, and Edison. A common trait among them was that they were ruthless in their risk taking and were not afraid of failure. They had a sort of what-if mentality in their endeavors, as they left no stone unturned in their quest of problem solving. Picasso filled stacks of sketchbooks before his masterpiece *Guernica* came to be. Einstein also had many notebooks filled with failed attempts at equations, and Edison had endless experiments that did not work. They were tenacious in their drive for discovery and did not let failure halt their attempts.

I truly believe that if you allow yourself to play you will unleash the painter that has been inside of you since you were that child at the easel years ago!

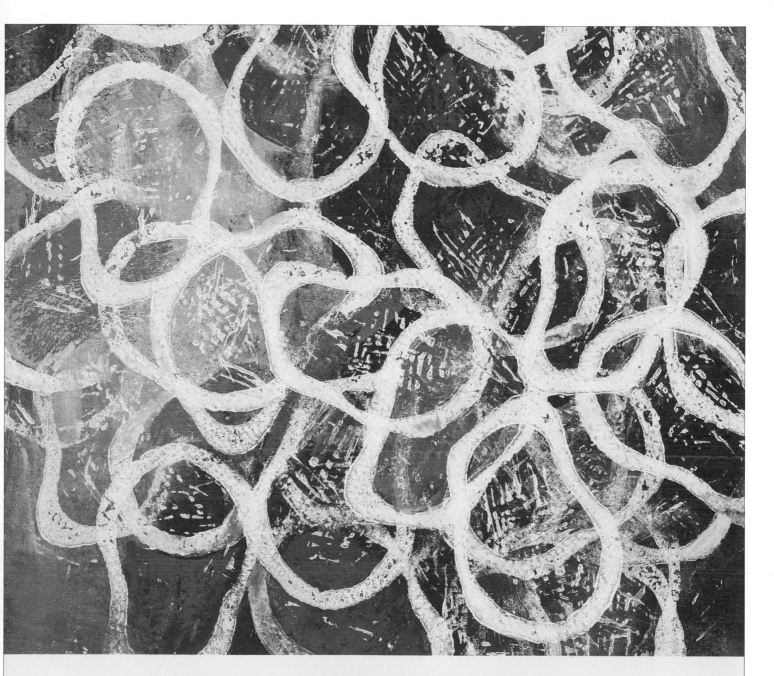

*"I hope this book will inspire you to play and take risks
without the worry of what the outcome will be."*

Getting Started

IN THIS BOOK you will find a wide array of projects and exploration of materials. Many of the projects are idea based; therefore, your preference for paints and materials can easily be plugged into the lab. The labs are merely structures to define and enhance your space to play and experiment. If you find yourself missing a specific material, substitute something else! Enjoy the process. And don't worry about the outcome. This chapter reviews some of the basic materials you will be using.

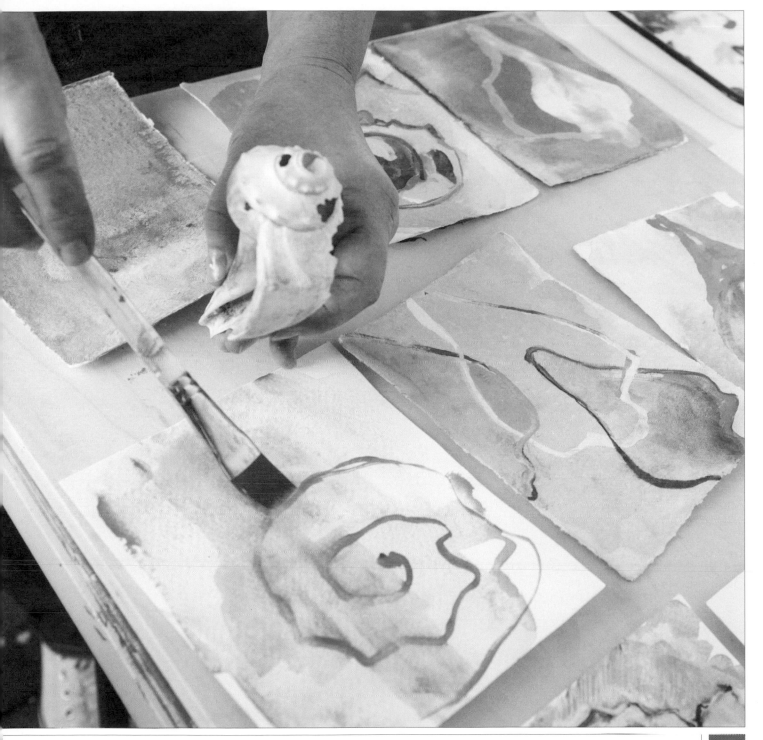

Work Area

You can work anywhere that is comfortable for you. This can be on a tabletop or upright at an easel. Lighting is important, especially for perceiving color, so make sure you have a good amount of natural light, or install extra lighting as needed. Clip lamps are very helpful and can be purchased at the hardware store.

Substrates

Many of the exercises explore innovative surfaces to work upon, but basic supports for this book include prestretched canvas in a variety of sizes. Canvas boards are also great supports. Paper is also a wonderful surface to work on, and I recommend watercolor papers or any high-cotton-content "rag" paper. These come in a variety of weights, from 180 lb to thicker. Explore the paper department in your local art store—it's fun! There are several online specialty art retailers, many of which are staffed with very knowledgeable personnel who can guide you in making selections.

Basic Materials

Here is a list of general supplies to get you started:

- 18" × 24" (45.7 × 61 cm) heavyweight drawing pad
- 180 lb inexpensive watercolor paper sheets
- 9" × 12" (23 × 30.5 cm) sketchbook
- black construction paper
- thin acetate sheets
- prestretched and primed canvases (various sizes) or canvas boards
- 2b and hb pencils
- white plastic eraser
- glue sticks
- pad of palette paper (small scale)
- 2 metal palette knives
- scissors
- 18" (45.7 cm) ruler
- craft knife with blades #1 and #11
- rubber-tipped stylus

GETTING STARTED

Paints

Water-based paints are generally easier to manage and generally better for your health. Begin with student-grade gouache, watercolor, and acrylic paints. Gouache offers a richness of colored pigment. Consider using it for many of the color theory exercises in the final unit of the book. Purchase acrylics in medium-size tubes. Golden's Fluid acrylics are a wonderful choice offering the same pigment strength as the Heavy Body acrylics in a pourable, low-viscosity formula. Gouache, oil, and watercolor come in all of the listed pigments and can be used for most of the projects in this book.

Basic Pigment Colors

- cadmium red med hue (spectrum red)
- quinacridone red
- alizarin red hue
- cadmium yellow light hue
- yellow ochre
- cadmium yellow deep hue

- ultramarine blue
- cerulean blue hue
- pthalo blue
- middle permanent green
- cadmium orange hue
- dioxazine violet
- titanium white (2 tubes)
- ivory black or mars black
- acrylic fluid gloss medium
- acrylic heavy gel medium

Mediums

Supplement your acrylic paint with a variety of mediums such as glazing medium, and a gel medium to create texture and body. Adding these mediums is the secret to creating rich luster in acrylic paint. Mediums can extend your paint. They can change the consistency making your paint thinner, thicker, harder, or softer. They can make the paint more translucent or more matte. A great site to learn more about acrylic paint is www.goldenpaints.com.

Brushes

Brushes for water-based paint tend to be soft, to aid in the absorption of water and to create flow in the strokes. Start with white soft nylon brushes in a variety of sizes such as wide flats, rounds, and filberts so that you have an expansive choice of paint application available to you, from broad washes to fine line work. A good way to test the quality of a brush is to give a little tug on the bristles; if many come out, don't get the brush. These hairs will then be in your paint! Clean your brushes in warm sudsy water with a mild baby shampoo to maintain their longevity.

Recommended Brush Sizes and Types

- ½" (1.3 cm), 1" (2.5 cm), and 2" (5 cm) flat
- wide hake
- very fine, medium-size, and large-size rounds

Cleanup

If you don't want a paint covered table, be sure to cover your work surface. A layer of newspaper or wax paper can be taped to your table and reused and disposed of when your finished. Rest your brushes in a jar of water while you're working, then wash them thoroughly when you are finished and store them with the bristles facing up. Acrylic paint will wash out of fabric while it's still wet, but once it's dry, it's fairly permanent. Consider an apron or designate suitable clothing for "painting." Keep one wet and one dry rag handy for wiping spills or even for removing paint from your substrate.

WHO:
Inspired by Artists

WHEN I WAS IN SIXTH GRADE our art teacher, Mrs. St. Florian, had us create a project inspired by Picasso's painting *The Three Musicians*. The assignment was to re-create the painting, and each student was given a piece of it to work from. Upon receiving my fractional square, I was amazed at the dots and dashes that Picasso used to enliven the surface, and his mastery of gray tones was evident even in my small section. This assignment made a huge impact on me at the age of ten, and it no doubt inspired and validated my journey as an abstract artist. Here, a known master of art was using a language of liberated, gestural mark making with basic mixtures of black and white paint, and I thought, "I can do that. I love doing that!" To this day art history provides a deep and endless source of inspiration in my teaching and in my own work. In this unit, the projects are inspired by an array of different artists, from Gerhard Richter to botanical illustrators. They are presented in the form of accessible and interesting projects in the hopes that you will also say to yourself, "I can do that!"

UNIT 2

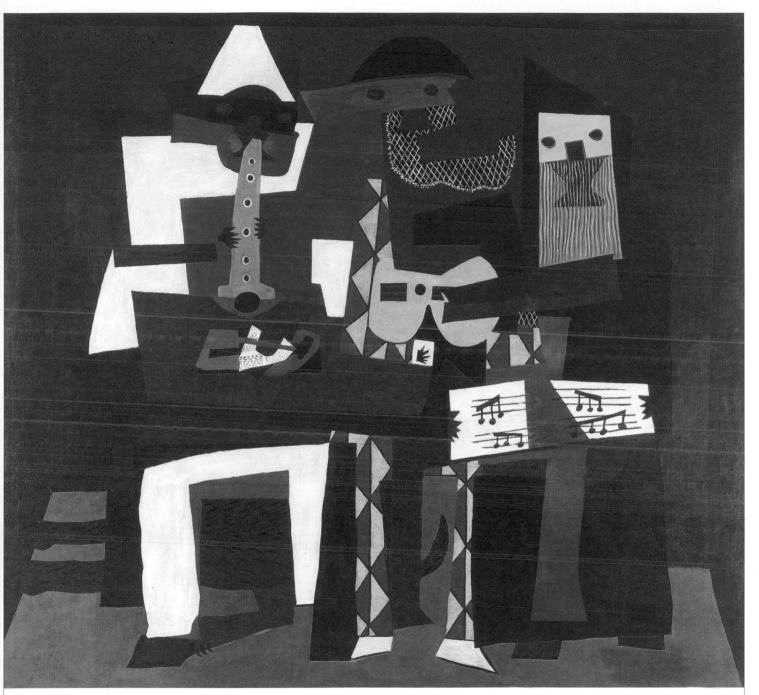

Pablo Picasso, *The Three Musicians,* oil on canvas, 1921

Inspired by Paul Klee:
Mark Making

- watercolor paper
- watercolor paints
- several small brushes
- pencil

The Swiss artist Paul Klee was an influential and masterful painter who worked mostly in the first half of the twentieth century. In his spirit, we will experiment with the optical layering of color and texture.

Lift, watercolor and gouache

Tip

When making your marks, try to pull and mix colors found in the initial layer to keep your colors harmonious and to transform and give an overall atmospheric depth to your painting.

Let's Go!

Fig. 1

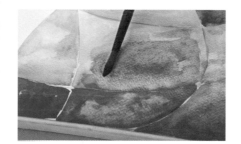

Fig. 3

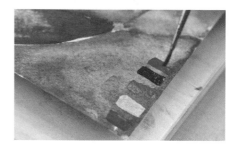

Fig. 4

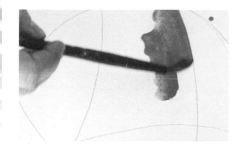

Fig. 2

1. On a piece of watercolor paper, create a simple composition. Begin with a circle and then travel through the paper with four intersecting lines (fig. 1).

2. Once you have your segments of shapes, begin to assign each one with a color field with the watercolor paint. Experiment with letting the colors bleed into one another (figs. 2, 3).

3. Once the painting is dry, begin to explore making marks on top of your colored forms to create a new frontal layer of texture (fig. 4).

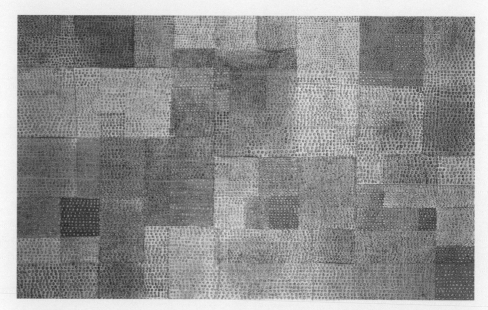

Paul Klee

Klee was trained in the European classical tradition but began to question and break away from his traditional methods when as a young man he visited Tunisia. There he saw the cultivated tradition of patterning and color interaction found in the tile work so pervasive in that region of the world. A changed man, he returned to Germany to explore in his own work for his entire life, painterly abstraction through the workings of color, geometry, texture, and symbol.

Above: Paul Klee, *Polyphony*, tempera, 1932

Materials

- fluid acrylics
- fluid acrylic medium
- multiple cups for thinning and pouring paints
- prepared paper or canvas surface

Of all the abstract expressionists, Helen Frankenthaler has always been one of my favorites. Like the abstract expressionists, she was process based, yet plugged in her unique style of pouring thinned-out washes of oil paint (eventually acrylic) directly onto the canvas.

Tip

It is a good idea to start with a light color and progressively get darker with the colors as the layers are built, but this is not a steadfast rule.

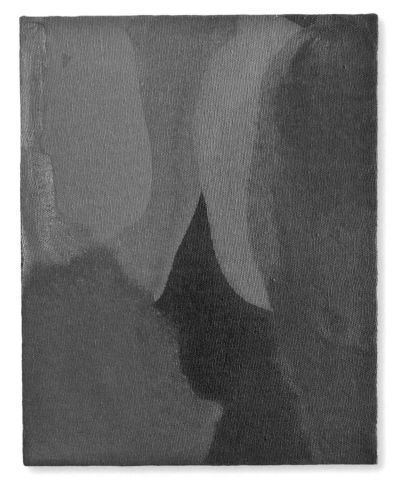

Petals, poured acrylic with limited palette

Let's Go!

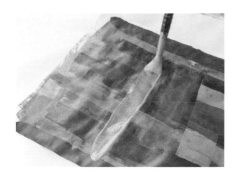

Fig. 1

Fig. 2

Fig. 3

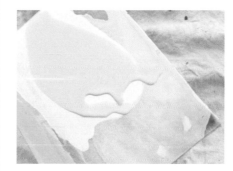

Fig. 4

Helen Frankenthaler

Frankenthaler created delicate and layered veils of chroma that ultimately created luminous color fields. Her ability to let the paint just be its drippy liquid self, connected her work to the magic of chance and the element of surprise. Sometimes letting go of controlling your medium can yield liberating results, and for Frankenthaler, this is her legacy. She wrote, "One is closest to one's self when one is closest to one's work, dreams and hopes, and making our own magic."

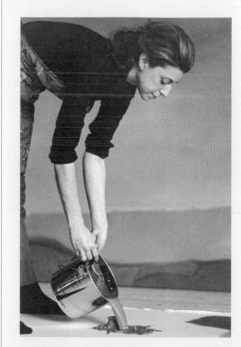

Helen Frankenthaler at work

1. Choose a palette that is limited to three to five colors and be conscious of how they will mix once poured and inter-mingling. You can do some experimen-tation with this on a scrap surface before starting (fig. 1).

2. Mix your cups of individual colors with a ratio of 1:1 paint and medium, and then mix this paint mixture with water with a ratio of 1:5. Emulsify and blend completely. You can even put a lid on the paint cup and agitate it gently to ensure this (fig. 2).

3. Let the paint pour over your canvas or prepared surface. You can also tilt the surface to encourage the color to flow in desired directions (figs. 3, 4).

4. Let the layers dry one by one if you want distinct veils of color and delineated forms. Also experiment with pouring the paint before the previous layer has dried to experience the interesting effects of wet-on-wet mixing.

LAB 3

Featured Artist—Keren Kroul:
Dreams

Keren Kroul is an artist raised in Israel and Costa Rica who currently resides in Minneapolis. The ornate and lush otherworldly imagery that she creates in her paintings are multilayered in scope as she looks partly to dreams and the subconscious for her inspiration.

Process

The process of making art is uncertain and imprecise; imagery and color respond to one another in the work, and follow their own need to expand, multiply, or dissolve. Working on paper with watercolor provides a sense of immediacy and spontaneity, enabling a recognition of things as they appear and allowing them to become a part of the visual vocabulary. Repetitive marks and the layering of watercolor echo the collecting of memories; in this way the work itself becomes a record of the passing of time.

Above: *It is possible*, watercolor on Arches paper

Right: *The still beauty of the place*, watercolor on Arches paper

"The dream is a little hidden door in the inner- most and most secret recesses of the soul."

—Carl Jung

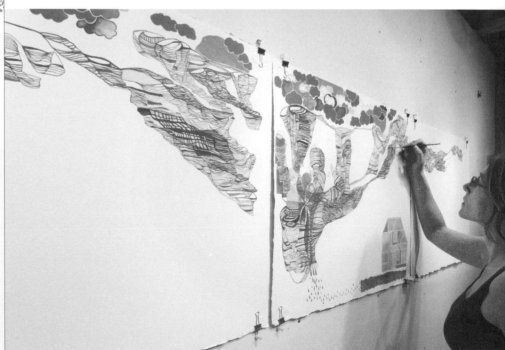

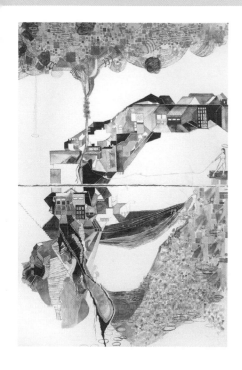

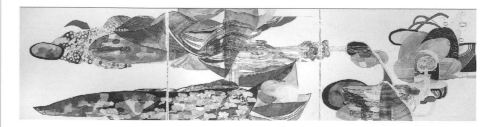

Imagery

The imagery is collected from memories, dreams, fragmented impressions, and emotions. References to being a mother—blurring of the boundary between self and child, connectedness with a larger truth, with the cycles of nature, and with the passing of time appear in the work as emotive organic elements, sometimes pouring out of the figure itself. References to the experience of alienation—separateness, being overwhelmed by blankness—are manifested in the work through cold architectonic passages and figures floating in the empty space.

Meaning and Content

In K'eren's work, tension between architectonic and organic elements reflects the interplay between place and memory, the structured and the visceral, logic and intuition. The figure, naked and exposed, acts as both the source and the vessel for these elements, connecting the many conflicted parts of the self. Her work dwells in this place of poetic adventure, where connectedness and alienation pull at each other, with the figure as the anchor.

Above left and bottom center: *Here everything returns upon itself*, watercolor on Arches paper

Above and bottom right: *How matter becomes conscious*, watercolor on Arches paper

Let's Go!

Try keeping a dream journal by your bed, and when you awake record some images from your dreams. Draw upon the content of this journal to generate the content of a painting.

Inspired by Gerhard Richter:
Squeegee

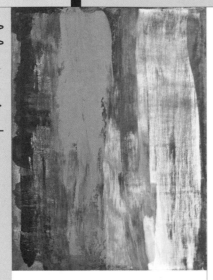

Gerhard Richter, alongside his realistic works, creates beautiful large-scale abstract paintings constructed entirely with paint and a squeegee (see www.gerhardrichterpainting.com and www.gerhard-richter.com). Working with a squeegee he removes the handmade quality of the brushstroke while still maintaining a spontaneous and energetic quality to layering the paint.

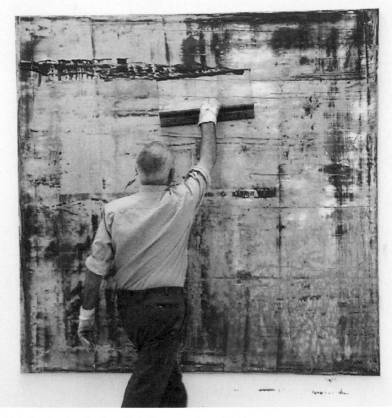

- squeegee (available in the printmaking section of an art store)
- acrylic glazing medium
- fluid acrylics
- primed canvas

Take It Further

Try crisscrossing the pulls from vertical to horizontal to create a woven pattern.

Above: Painting for the Corinna Belz Documentary, 2011

Top left: *Ghost*, acrylic on canvas

Let's Go!

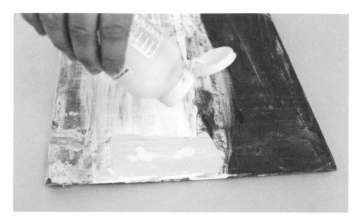

Fig. 1

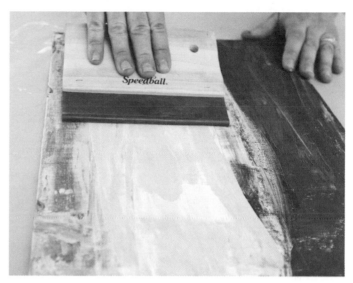

Fig. 2

1. Start by honing down your palette to four or five colors. Try also to include colors that are naturally transparent such as zinc white.

2. Put the paint down on top of the surface and add a little medium to increase the flow and transparency of the pull (fig. 1).

3. Put the squeegee down into the paint and slowly, steadily pull the color to your desired length. Do not put too much pressure on the tool (fig. 2).

4. Revisit painting after some of the layers are dry, and keep building up the surface as you did in step 3 (fig. 3).

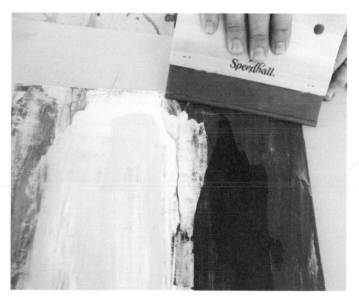

Fig. 3

Gerhard Richter

Richter is a fascinating contemporary artist who is known mostly for his stunning post-modern photorealistic paintings that deal often with the complexity of German identity in the twentieth and twenty-first centuries.

LAB 5

Inspired by Kazimir Malevich:
Spare Geometry

Materials

- black and white paper
- scissors
- glue stick
- paint (gouache used here)
- graphite paper
- painting surface (watercolor paper used here)

Russian artist Kazimir Malevich created fascinating works due to his trailblazing forays into abstraction. In the early twentieth century in the canon of suprematism, and later constructivism, his paintings explored the essential power of distilled geometric form and color. In this project use a collage as a springboard to experiment with varying palettes and to see if you can evoke a different mood or feeling for each piece.

Kazimir Malevich

Malevich was a renegade in his rejection of a painting as an illusionistic window as he communicated feeling graphically through totemic-like forms and their careful placement in the picture plane. "He believed that there were only delicate links between words or signs and the objects they denote, and from this he saw the possibilities for a totally abstract art. And just as the poets and literary critics were interested in what constituted literature, Malevich came to be intrigued by the search for art's barest essentials." (www.artnet.com)

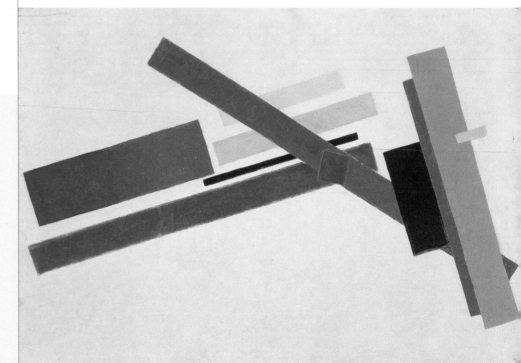

Severinovich, suprematist construction, oil on board

Let's Go!

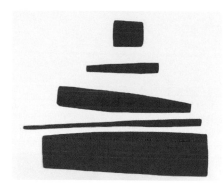

Fig. 1: *Step-up*, black-and-white paper

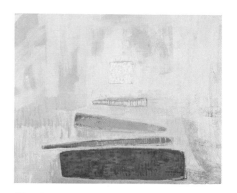

Fig. 2: *Yellow #1*, gouache on paper

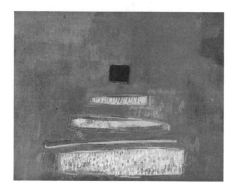

Fig. 3: *Magenta #2*, gouache on paper

1. A clear way to make composition your focus can be found simply by creating a collage with black and white paper (fig. 1). Play around with cutting different forms and repositioning them on the paper. Let the collage process guide you so you are open to the possibilities of play. Glue the pieces in place.

2. Transfer the collage design using graphite paper onto desired surface. Any kind of surface will work. Here I use watercolor paper and gouache (fig. 2).

3. Experiment with varying palettes (fig. 3).

Tips

• Composition and placement of form are an integral part of the overall success and potency of a work of art.

• A good way to explore the collage process is to take a design, cut it up, and then reposition it. This technique always delivers new unforeseen possibilities (See "Lab 45").

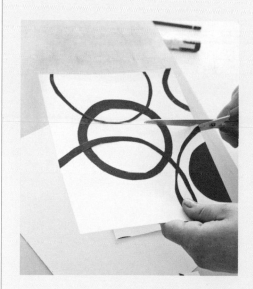

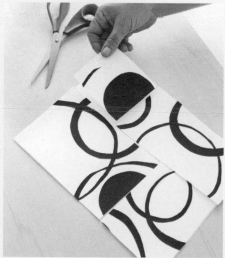

Inspired by Svenska Vaxter:

Botanical Illustrations

- plant forms
- craft knife
- paper
- any kind of paint

Hanging in my living room growing up was a botanical poster by Swedish artist Svenska Vaxter that I always loved. These historical posters were abundant and common-place in the European class-room from the 1800s through the mid-twentieth century. I was drawn to the interplay of both science and art. They are a great place to look for content and imagery in a painting. Rather than adhering to a strictly biological premise, I encourage you to use this multifaceted examination of an organic form as a spring-board to explore composition and color.

Florilegia

A *florilegium* is a compilation of botanical illustrations of ornamental flowers, which are often rare or exotic and from local areas as well as foreign regions. These types of books were first created in the fifteenth century and then flourished in the seventeenth century, often commissioned by wealthy individuals or botanic gardens. Artists were to record the detail and beauty of these exotic plants. Currently, *florilegia* are created to record plants that are often endangered or from a particular place.

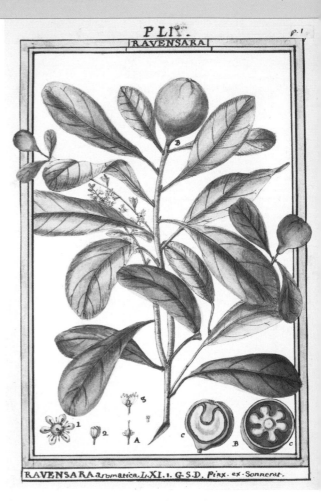

Cryptocarya Aromatica, watercolor, 1789

Let's Go!

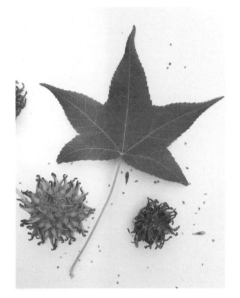

Fig. 1

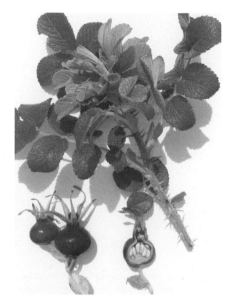

Fig. 2

Fig. 3

1. Select a plant form that interests you; take a sample of leaves, branches, seedpods, or blooms. My choices here are from a sweet gum tree (fig. 1) and a beach rose (*Rosa rugosa*) (fig. 2).

2. Dissect the plant with a craft knife to view any interesting interiors of the plant forms and begin to sketch these different elements (fig. 3).

3. Apply these sketched and examined forms in various combinations on a larger piece of paper to create an interesting composition and explore these forms with invented color (figs. 4, 5).

Fig. 4: Sweet gum study, gouache on paper

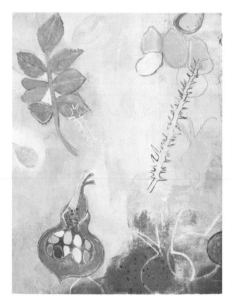

Fig. 5: Rose hip study, gouache on paper

Inspired by Georgia O'Keeffe:
Zoom In

In the early twentieth century, Georgia O'Keeffe was a pioneer of abstract painting, in particular American Lyrical Abstraction. Using nature as her muse, she would explore amplified expressive color in the painting process. In this exercise, we will magnify a small form to generate a larger piece with expressive color.

- organic forms still life (bones, flowers, fruits, etc.)
- viewfinder
- sketch paper
- pencil
- paint

"I decided that if I could paint that flower in a huge scale, you could not ignore its beauty."

—Georgia O'Keeffe

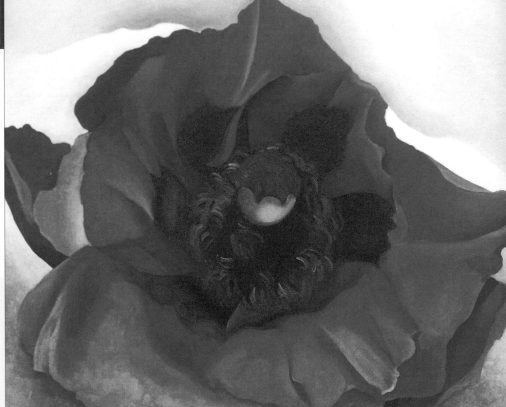

Above: Georgia O'Keeffe, *Poppy*, oil on canvas, 1927

Top left: *Blue seeds*, acrylic on paper

Let's Go!

Fig. 1

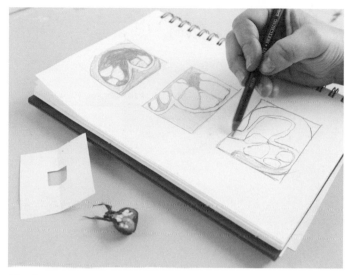

Fig. 2

Fig. 3

1. Select a form that interests you to examine (here I have used the rose hip).
2. Create a simple viewfinder from paper as a way to help image various compositions of the form when zooming in (fig. 1).
3. Create multiple sketches before beginning your painting to find a composition that interests you (fig. 2).
4. Transfer this onto large paper or canvas and begin to paint (fig. 3).

Georgia O'Keeffe

The perhaps most famous female artist of all time looked to nature as her inspiration. She worked in a canon of true abstraction in that she would examine a form, and then extrapolate and distill the essential elements of that form into her painting. "When you take a flower in your hand and really look at it, it's your world for the moment. I want to give that world to someone else. Most people in the city rush around so, they have no time to look at a flower. I want them to see it whether they want to or not."—Georgia O'Keeffe

Inspired by Fibonacci:
The Golden Ratio

LAB **8**

Materials

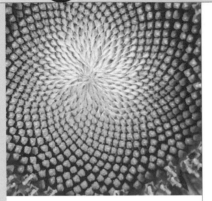

- hard-copy version of the golden ratio (easily found on web)
- graphite transfer paper
- pencil
- tape
- paper
- paint

This project is inspired by math, believe it or not! Fibonacci created the formula known as the golden ratio, which applies to the organic growth process from the spiral of a sunflower to the spiral of a whirlpool galaxy. We will look to this formula to inspire a sense of balance and structure in a painting that is bound to the very core of the mysteries of the natural world.

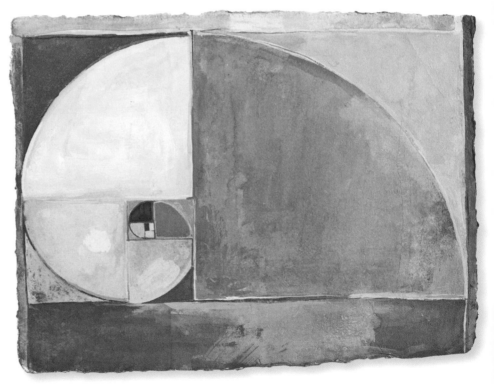

Golden ratio study, gouache and watercolor on paper

Let's Go!

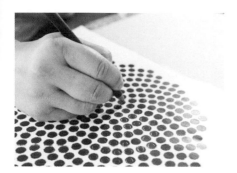

Fig. 1

Fig. 2

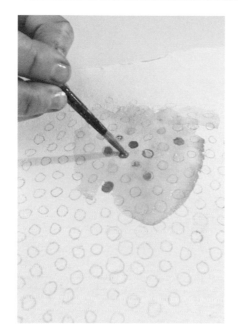

Fig. 3

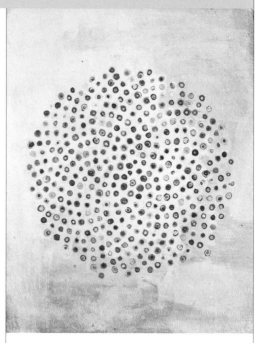

Whorl study, gouache and watercolor
on paper

1. Find an exemplified image of the
 golden ratio from the Web.

2. Trace this form onto your paper using
 the transfer paper and a sharp pencil
 (figs. 1, 2).

3. Experiment with layering your paint in
 washes with one color on top of the
 other (don't paint by number—you will
 go crazy!) until you begin to get color
 language that complements and
 enhances this powerful design (fig. 3).

Leonardo da Pisa

Also known as Fibonacci, da Pisa was a twelfth-century mathematician who (influenced by
Indian mathematics) discovered a sequence of numbers that describe exponential growth.
These proportions are found all through nature, including plants, the human body, many
animals, and insects such as the honeybee.

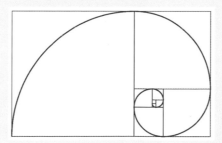

*A Fibonacci spiral created by drawing
circular arcs connecting the opposite
corners of tiled squares, which are
successive Fibonacci numbers in length:
1, 1, 2, 3, 5, 8, 13, 21, and 34.*

LAB 9

Inspired by Frida Kahlo:
The Self-Portrait

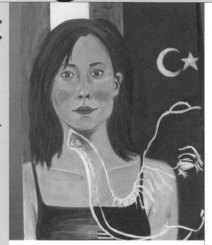

- large canvas
- paint
- reference materials of imagery to add into painting
- mirror or photograph
- charcoal

"I paint self-portraits because I am so often alone, because I am the person I know best."

—Frida Kahlo

Frida Kahlo was a Mexican artist who devoted her life's artwork to the self-portrait. In this project, look at aspects of your life as you weave your own symbolism into your self-portrait.

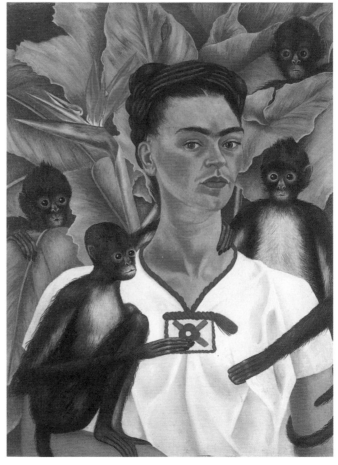

Above: Frida Kahlo, *Self-portrait with monkeys*, 1943

Top left: Selin Ashaboglu, self-portrait, oil on canvas

Let's Go!

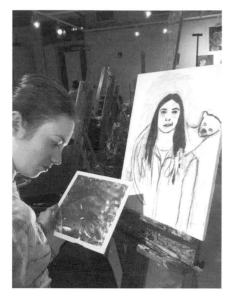

Fig. 1: India Dumont, work in progress

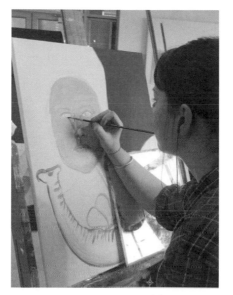

Fig. 2: Selin Ashaboglu, work in progress

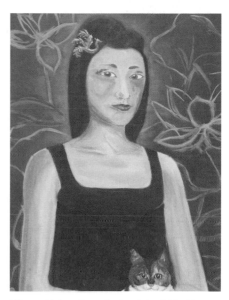

Yitong Cai, self portrait, oil on canvas

1. Begin to brainstorm what you would like to incorporate into this self-portrait. Some inspiration that my students have used have been a specific landscape that they place themselves within, animals that they feel a connection to, as well as maps and flags that represent a specific region.

2. Begin by creating a composition that incorporates the different elements onto the one large canvas in charcoal (fig. 1). Be mindful not to overwhelm the canvas with too many elements.

3. Begin painting your piece with a total of four colors to maintain harmonies (figs. 2, 3).

Fig. 3: Yitong Cai, work in progress

Frida Kahlo

Kahlo lived most of her life in Mexico. After being injured in a bus accident, her father introduced her to painting to help fill the time during her recovery. The complexity of her cultural identity and the inspiration of the animals, flora, and fauna of her homeland provided a bottomless well to draw from in her work.

Inspired by Children's Art:
Acetate Monotypes

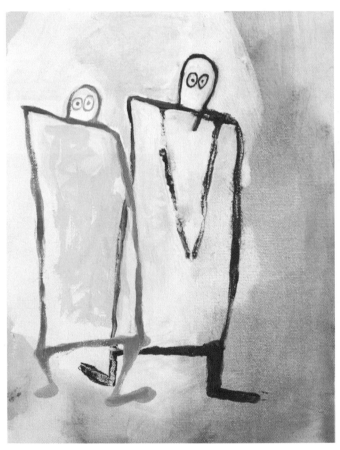

In children's art, those first years of representation are so interesting as they tend to repeat certain shapes to depict form. My son, Nathaniel, has always enjoyed drawing, and I find his work so inspiring because of the inventiveness, confidence in the line and form, and lack of restraint. I wanted to find a way to combine the work with my own; so here we have the acetate monotype!

- thin acetate (.005 or .010)
- child's line drawings
- oil paint
- pre-painted ground on rigid surface
- brayer

"Around here, however, we don't look backwards for very long. We keep moving forward, opening up new doors and doing new things, because we're curious . . . and curiosity keeps leading us down new paths."

—Walt Disney Company

Duo, oil and acrylic on canvas

Let's Go!

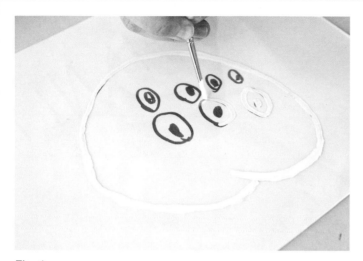

Fig. 1

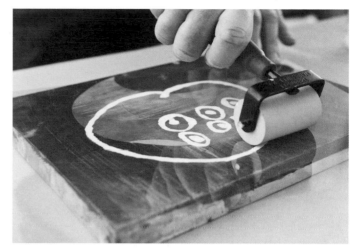

Fig. 2

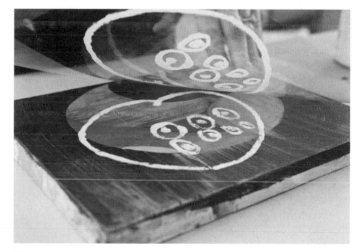

Fig. 3

1. Select one or two drawings that you find intriguing.
2. Place the acetate over the drawing and, with oil paint, trace the line with a medium-thick layer of paint (fig. 1).
3. Place the painted acetate facedown on your surface and roll the brayer on the unpainted side of acetate to ensure transfer (fig. 2).
4. Carefully lift off and repeat if desired (fig. 3).

Tip

This technique will actually work for anything that you can trace, including leaves and photos.

WHAT:
Exploring Your Media

WHEN I WAS A CHILD, and through my college years, there was a fantastic art supply store called Oakes on the Hill in my hometown of Providence, Rhode Island. This place was housed in a building from the 1800s, and I used to love the loud creaks of the slanted, wooden floorboards as I walked through the aisles. Even as a child, I was entranced by the brightly colored tubes of paint, the sticks of pastels (like candy in deep bins), and the draped sheets of fabrics, from fine duck canvas to Belgian linen. It was a magical place full of possibility of what one could create with all of these materials. To this day I still feel that same excitement when I squeeze out my color onto the palette or experiment with a new kind of painting surface. This unit pays homage to the excitement and possibility found in exploring an array of materials that includes plaster, metal, and burlap, to name just a few.

Materials

In this project, we will explore utilizing masking fluid to convey atmospheric depth, by painting with transparent colors to create buried subterranean forms in your painting.

- masking fluid
- disposable brushes
- watercolor or gouache paint
- watercolor paper

"The creative process is a process of surrender, not control."

—Julia Cameron

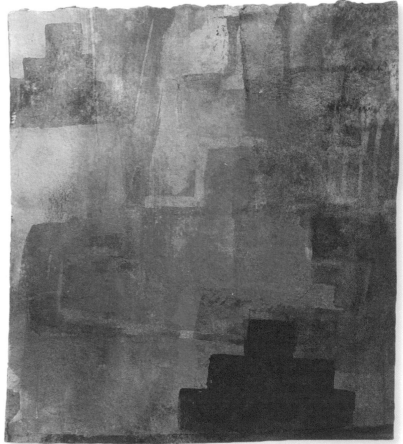

Seated Steps, watercolor on paper

Let's Go!

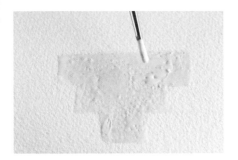

Fig. 1

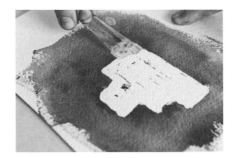

Fig. 3

Fig. 6

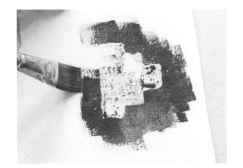

Fig. 2

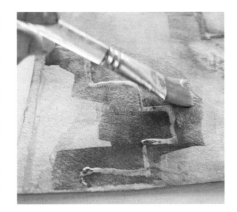

Fig. 4

Fig. 5

1. In a well-ventilated area, begin to apply your fluid on the blank white paper. Choose simple forms to encourage exploration of the materials (fig. 1).

2. Once the fluid is dry to the touch, begin with your layers of watercolor or gouache paint (fig. 2).

3. Remove the masking fluid (fig. 3) and then keep repeating steps 1 and 2 (figs. 4, 5) until you are satisfied. Keep colors washy and transparent (fig. 6).

Masking Fluid

Masking fluid medium is a material best used with watercolor or gouache paints. It is composed of latex rubber, and it allows you to freeze a moment of time in your painting as the fluid preserves your color and resists additive paint. Besides clear masking fluid there is colored masking fluid, which allows you to see where you placed it. This material will ruin the softness of a brush, so designate brushes to only be used for masking fluid.

Materials

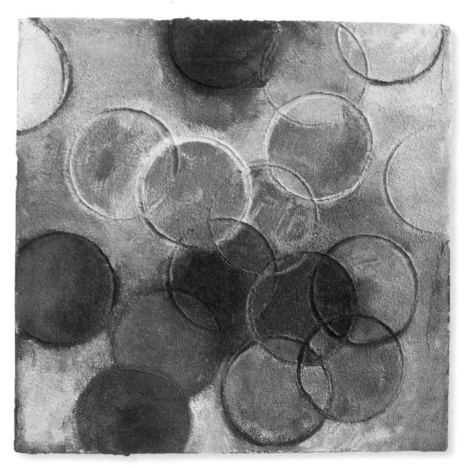

- acrylic pumice ground
- large palette knife
- any surface
- tools to make prints or marks
- acrylic paint

"I've been absolutely terrified every moment of my life and I've never let it keep me from doing a single thing that I wanted to do."

—Georgia O'Keeffe

Pumice ground is a great acrylic medium to experiment with as it creates a rough and absorbent surface that captures the paint in a unique and earthy way.

Links, pumice and acrylic on canvas

Let's Go!

Fig. 1

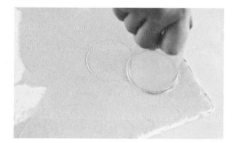

Fig. 2

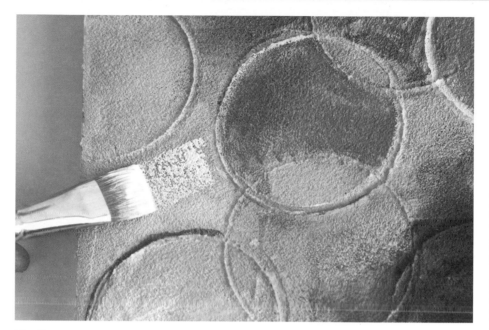

Fig. 3

1. With your palette knife, add a healthy amount of acrylic pumice ground onto your surface and begin to spread (fig. 1).

2. Once you have the desired layer, take a tool to create marks and relief texture into the ground (fig. 2).

3. Once it is dry, paint directly onto the ground. Keep layering the color until the ground is embedded.

4. On the uppermost layers, experiment with dry brushing, which means loading only paint and no water on your brush so that the pigment holds the texture of the stony surface. This is a great way to create depth, while maintaining the underlying colors (fig. 3).

Pumice Ground

Acrylic is such an exciting medium to work with today due to the variety of interesting grounds and mediums available. Pumice ground is made with pulverized volcanic stone suspended in acrylic polymer. You can obtain it in various textures from fine grain (pictured) to very chunky and gritty. Another great feature of this material is that due to its thickness, you can embed marks into the initial layer as it goes down. You can also tint the pumice ground with a color before applying if you do not want a gray ground.

Featured Artist—Michael Lazarus:
Beyond the Canvas

Michael Lazarus is a painter based in Portland, Oregon, who creates vibrant evocative paintings placed upon cut wooden forms that he constructs himself. Breaking away from the rectilinear surface and exploring new shapes to paint upon is an exciting endeavor, as it will bring a new element to the overall piece. Michael works mostly on wood, but you could easily do this with cut paper forms as well.

Above left:
Caution, acrylic paint, found objects on wood

Right:
Push, acrylic, collage, and mirror on wood

Opposite left:
Echoing, acrylic, collage, and mirror on wood

Opposite center:
Tethered, acrylic paint, found objects, wood,

Opposite right:
On, acrylic paint, found objects, tape, on wood

Let's Go!

Try exploring innovative surface shapes for your work by cutting blank pieces of watercolor paper into non-rectilinear forms and assembling them together to begin your piece. (See Elizabeth Murray drawings at www.pbs.org/art21/artists/elizabeth-murray.)

Q: What inspired you to incorporate these non-rectilinear forms?

A: It began at first when I was working with the white of the wall 'entering' the work. At the time, the work was primarily enamel paint, and I began using flat white wall paint in some shapes that came off from the edge of the panel to have the white of the wall, in a way, enter the work. I liked this, giving the relationship between the work and the wall another aspect. Then there was a piece where I expected to use this same approach but instead, something said to me, 'Why do you need that area to be there at all? If it's not important to the work, it shouldn't be there.' So I cut it away. There it was—the work was now only what it needed to be.

Q: What do these shapes lend to your imagery that you place upon them?

A: Sometimes it emphasizes that a void is a void. Sometimes it creates an interaction with the wall, bringing the wall into the work, making the wall itself part of the work. Sometimes it accentuates that a painting is an object. Most of the time, it does some of all of these, and hopefully more.

Q: Talk about your painting process and materials.

A: Currently I am primarily working with acrylic paint, collage, and found materials. My most recent work is using more and more found materials, less paint, and less use of rectilinear formats. But I still am, as a very conscious decision, making paintings, with all the historical and cultural meanings that come with this.

I make my paints with pigments that I add to medium, primarily a very high-gloss, 'hard' film medium creating a similar feel to enamel paint. By mixing my own paints I can control the percentage of pigment, and I can use more pigment than

premixed paints have, creating a more intense hue.

In my studio I have a large collection of collage materials and found materials such as wood, signs, bottle caps, etc. It's like having lots of colors of paint sitting on the table: I'm not going to use all of them on this one piece, but if there is one I need I know it's there, or maybe I look over and see it sitting there and it hits me: 'Use this.'

Most works start out on a rectangular piece of plywood. I begin the work with the painting itself—there are no preliminary drawings. Once I have gotten a bit into it, then in my notebook I will make a diagram of what I have and start to think about possibilities for what is next, noting these down. This process goes back and forth, between working on the piece and writing about it, until the work is finished.

Photos courtesy of Matthew Miller.

LAB 14 Burlap as a Painting Surface

Materials

- burlap (tightest weave you can find)
- heavy acrylic gel medium
- gesso
- palette knife
- prepared canvas or panel
- oil or acrylic paint

Burlap has such an earthy quality and makes for a very interesting surface upon which to paint. In fact, it was a favorite for the famous Bauhaus-era artist Paul Klee. It lends a rough textural element to your ground, and unlike duck canvas it contributes an organic irregularity to the overall piece. I got a few bags for free from my local coffee shop. Thank you, Coffee Exchange!

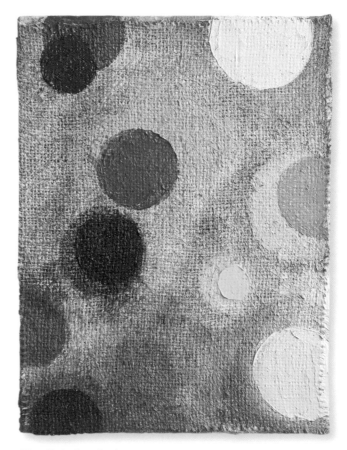

Blue Dot, oil on burlap

Paul Klee, *Heroic Roses*, oil on burlap

Let's Go!

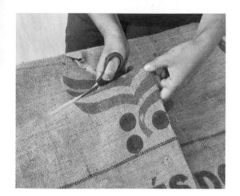

Fig. 1

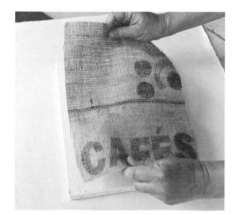

Fig. 2

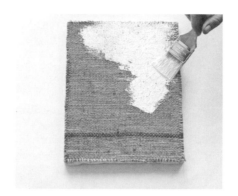

Fig. 3

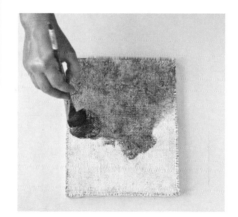

Fig. 4

Take It Further

When cutting the burlap, select an interesting part of the bag graphic that you can possibly incorporate into your painting. After the burlap is adhered to the canvas, prime it with a clear coat of acrylic medium instead of white gesso to play with maintaining the graphics and natural qualities of the fabric. This will lend more of a collaged, found-object feel to your piece.

1. Take your canvas and trace the shape over the burlap to get the correct size (fig. 1).

2. Apply a thick layer of acrylic gel medium to the canvas with your palette knife, as if you were applying frosting. Place the burlap piece onto this and smooth it down so that it is fully adhered (fig. 2). Let this dry.

3. When the burlap is dry, prep the entire surface with gesso (fig. 3).

4. Experiment with embedding and almost scrubbing a layer of paint into the crevices of the burlap to create atmospheric effects and to bring out the texture of the fabric. This is akin to inking up a printing plate (fig. 4).

5. Begin to layer paint onto this scrubbed surface.

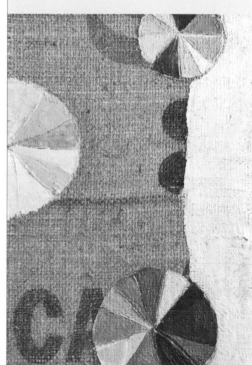

Pies, oil on clear, polymer-primed burlap

Mask It Out:
Stripe Exploration

- various widths of painter's tape/artist's tape
- prepared canvas or rigid surface (wood panel used here)
- acrylic paint
- heavy gel medium
- wide palette knife
- transparent colors

Painting is more like building a layer cake than putting together a jigsaw puzzle. There is a richness to be found in the depth of building up veils of color. Masking tape is one of many tools for achieving this. By blocking out areas of your painting, you also honor the history of your work by maintaining and showing the earlier layers. There is an element of surprise that comes with masking out that makes the tape removal fun!

Painting is more like building a layer cake than putting together a jigsaw puzzle.

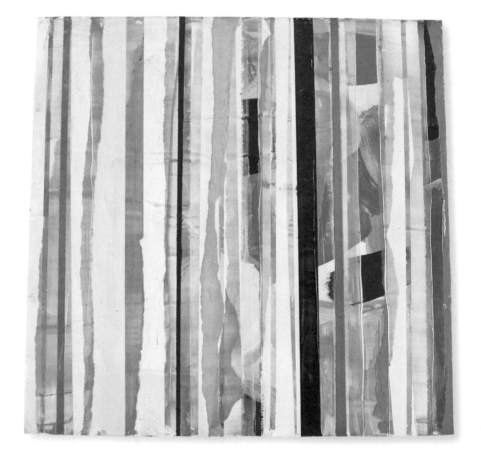

Pink Harp, acrylic on panel

Let's Go!

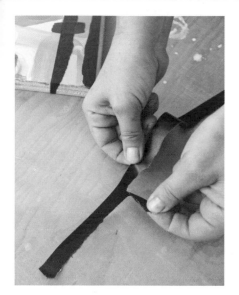

Fig. 1

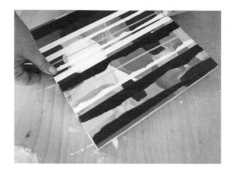

Fig. 2

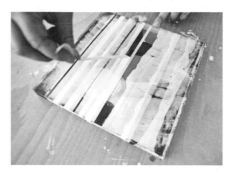

Fig. 4

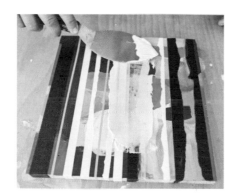

Fig. 3

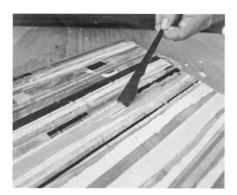

Fig. 5

1. Create a loose multicolored under-painting on your surface. You want to have a dynamic first layer.

2. When dry, begin to apply your design with the tape. Explore ripping the tape to create more organic edges (fig. 1).

3. Be mindful of what areas you are masking and also to the negative space in between your pieces of tape. Press tape firmly onto surface for a clean removal (fig. 2).

4. Mix up a transparent color with enough gel medium to cover your surface. I used a ratio of 1:5. Spread this over your taped surface (fig. 3).

5. Remove tape once the gel layer has partly dried (fig. 4). Let this dry and start from step 2 again for a multilayered color. Repeat as much as you like to play with depth of color and texture.

6. It is also fun as you get to the top layers to swipe in one color at a time for impact, as you begin to hone your color interaction (fig. 5).

Tip

Look on the back of your paint tubes to see if the paint is transparent or opaque. For this project, use transparent paint to build up colors rather than covering up the previous hue.

16 Textiles as Inspiration

- printed fabric
- wooden stretcher bars
- staple gun or tacks
- acrylic medium
- paint

Robert Rauschenberg was an American artist who pushed forward the evolvement of painting from Abstract Expressionism into the Pop Movement. He did so by incorporating everyday materials such as textiles and domestic objects as a means to mix the high and the low in his work. Printed found cloth can bring a familiar sensibility to your work, as well as a historical and cultural evocation from the fabric that you use.

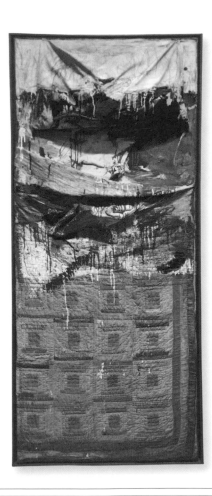

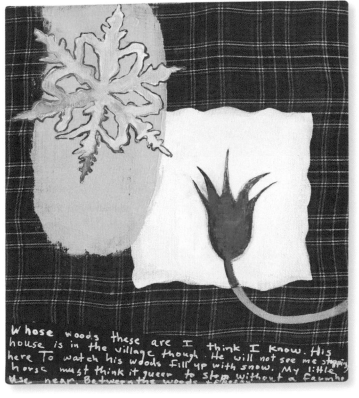

Above: *By the Woods*, acrylic on tartan plaid fabric

Left: Robert Rauschenberg, *Bed*, 1955

Let's Go!

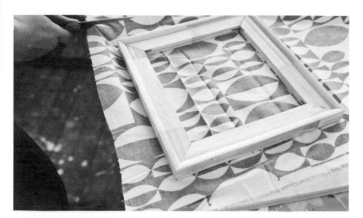

Fig. 1

Fig. 2

Fig. 3

Fig. 4

1. Select a fabric that inspires you, and then cut it to stretch over a wooden frame (figs. 1, 2).
2. Once stretched, apply a layer of acrylic medium on the front and back of the stretched painting to size it and to make it tighten up (fig. 3).
3. Once dry, begin painting (fig. 4).

Tip

In this piece (right), the plaid reminded me of a New England garb and then that inspired me to include my favorite Robert Frost poem, "Stopping by Woods on a Snowy Evening." I did not know I would do this—the fabric guided me. Try seeing where a fabric will guide you.

Hard Molding Paste
with Stencils

Hard molding paste is another great acrylic medium to explore. In this project, use stencils with the medium to repeat a specific form on a canvas to create a semi-relief effect.

- hard molding paste (such as Golden)
- palette knife
- paper or acetate stencil
- canvas
- acrylic paint
- craft knife

"If I create from the heart, nearly everything works; if from the head, almost nothing."

—Marc Chagall

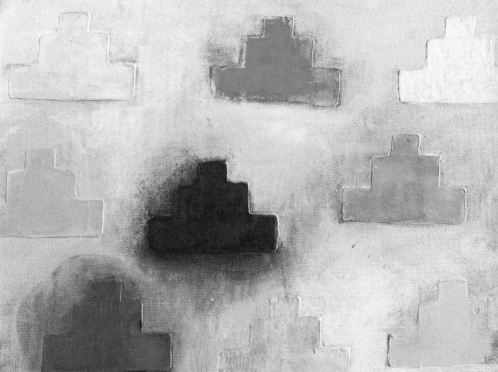

Nine Steps, acrylic and molding paste on canvas

Let's Go!

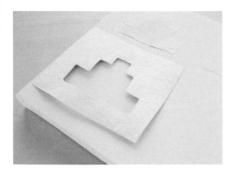

Fig. 1

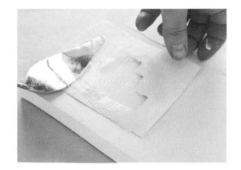

Fig. 2

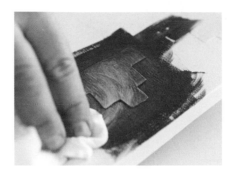

Fig. 3

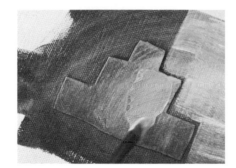

Fig. 4

Hard Molding Paste

This medium is an acrylic polymer combined with marble dust that finishes hard to the touch. Hard molding paste has an endless amount of applications creating a stiff and bumpy texture in your painting. Molding paste can also be mixed with colored acrylic paint (fig. 5), yet it will tint the color with the white of the marble dust. You want to clean this off of your brushes and tools right away, because the paste sets quickly. Molding paste can be applied in heavy layers and is also great for creating thick peaked brushstrokes in an acrylic painting.

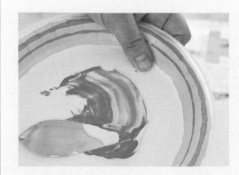

Fig. 5

1. Create the stencil with either paper or acetate by just drawing a form and cutting it out with a craft knife. Place this on your canvas and thickly layer the molding paste over the stencil (fig. 1).

2. Carefully lift off the stencil while the paste is still wet (fig. 2).

3. Once dry, paint a layer over the semi-raised shape and wipe away the excess to reveal the sculptural aspects of the form (fig. 3).

4. Keep building up the layers (fig. 4).

Crackle Paste:
The Worn Surface

Materials

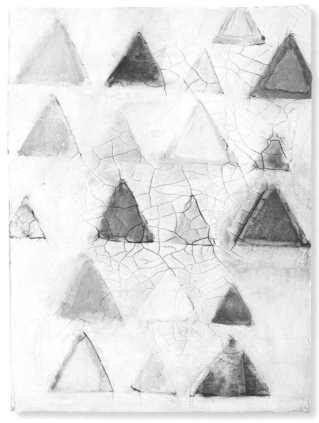

- crackle paste
- paper or acetate stencil
- hard molding acrylic paste (see "Lab 17")
- canvas or rigid surface
- palette knife
- acrylic or oil paint

Crackle Paste

The paste is best applied evenly and thinly to get a uniform cracked appearance. Paint very lightly on top of the paste with an acrylic wash before it is fully cured so the image will "crack" on the top surface.

Here is an example of another really fun acrylic polymer tool to play with. The crackle paste lends an air of something ancient and ruinous to your work, which can be a very interesting quality with which to experiment. This project uses the timeless form of the triangle to tie thematically with the ancient-feeling quality of the material. There are endless ways to incorporate this crackle effect into your paintings.

Three Points, acrylic and crackle paste on canvas

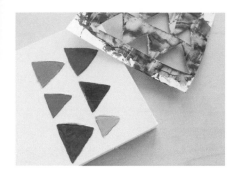

Fig. 1

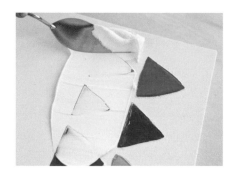

Fig. 2

Fig. 4

1. Create a simple paper or acetate stencil with your desired form, and apply pigmented molding paste to create a series of forms on your surface (fig. 1). Let dry. See "Lab 17."

2. Layer crackle paste over your raised forms. Layer it thinly enough so that you can still detect the forms below (fig. 2). Let this layer cure for about two days (fig. 3).

3. Once it is dry, layer a dark acrylic wash into the cracked texture and then swipe away the excess to accentuate and embed the darker color into the cracks (figs. 4, 5).

4. Keep painting and building up the surface to maintain the cracks. Work with delicate washy layers.

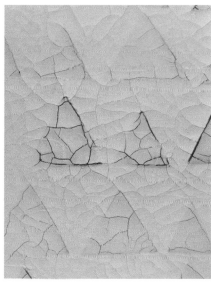

Fig. 3

Fig. 5

Take It Further

Layering the geometric forms with crackle paste conveys a buried fossil-like appearance. You could also collage paper forms or written words beneath the layer of crackle paste. This material would be very interesting layered over a form inspired by Fibonacci in Lab 8.

Drawing into Painting:
Playing with Oil Sticks

- oil sticks
- underpainting
- palette knife for scratching away (see "Lab 22")

Oils sticks are a wonderful medium to incorporate into an acrylic or oil painted surface. They are composed of wax, linseed oil, and pigment, and they come in a variety of sizes from thick to thin. Oil sticks bring a bravado dash of line and fresh color onto your surface. It is also fun to let the under-painting peek through the oil stick layer, or to scratch through the oil stick layer with your palette knife to reveal the color story beneath.

"They're only crayons. You didn't fear them in Kindergarten, why fear them now?"

—Hugh MacLeod

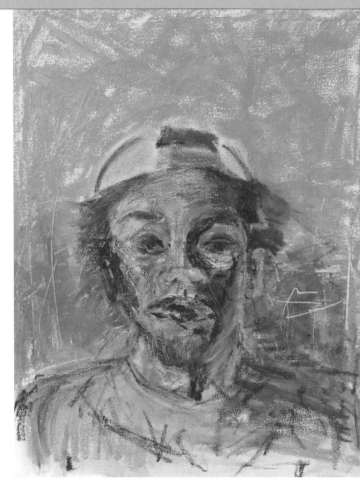

Stephanie Hoomis, portrait study, oil pastel and acrylic on canvas

Let's Go!

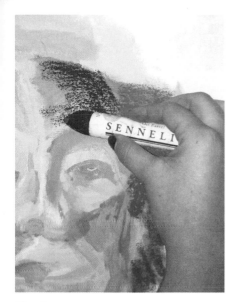

Fig. 1

Fig. 2

Fig. 3

1. Begin with an underpainting upon which you will draw. You can keep this to a sketchy level and plan to refine with the oil sticks. Try to create basic forms and shapes that you can further define and build into with oil sticks. (fig. 1).

2. Select three or four oil sticks that are harmonious with your underpainting and begin to experiment with layering (fig. 2).

3. With your palette knife, explore scratching away the oil stick layer to create texture and reveal the colors underneath (fig. 3).

Oil Sticks

The Sennelier brand oil sticks are as creamy as lipsticks and come in beautiful colors! Oil sticks can also be painted into with turpentine and linseed oil to create thin washes. It would be interesting to do a very linear drawing with these, and to then soften these lines with a solvent wash to get transparent effects.

Note: You cannot use water-based media on top of the oil stick.

A Secco:
Painting on Plaster Surface

Materials

- roll of dry plaster fabric
- water
- primed canvas or any rigid support such as a wood panel
- water-based paints (acrylics used here)

Fresco means "fresh" in Italian, and it is a process that involves the layering of pigments upon wet or damp lime plaster. Frescos have a unique jewel-like quality due to how the chroma becomes soaked into the surface of the plaster. This Lab demonstrates how you can re-create this brilliant and unique effect with basic plaster strips applied to a canvas.

Secco

The term *a secco* is a fresco term for layering upon dried plaster, which is what is shown here. *Secco* means "dry" in Italian. This was a very popular style of painting mostly prominent during the late Medieval, early Renaissance period in Italy. Although, the earliest forms of this method of painting delves back even further to 1500 BC in Crete of ancient Greece.

You can experiment by applying Venetian plaster onto a primed, rigid wooden surface and create texture with a trowel. When applying plaster strips to canvas, lightly mist the canvas first.

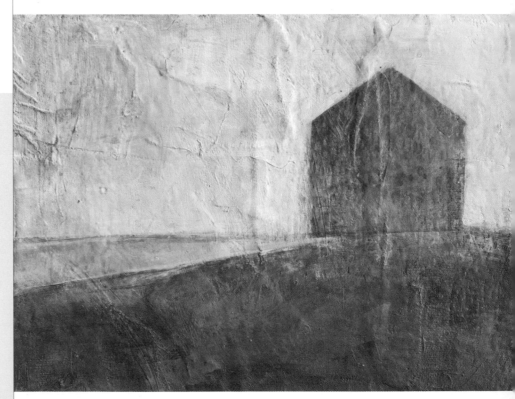

Bluehouse, plaster and acrylic on canvas

Let's Go!

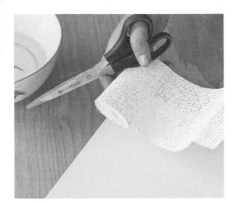

Fig. 1

1. Cut the plaster strips into various shapes (fig. 1).

2. Wet the strips and begin layering onto the canvas (fig. 2). Have fun with the irregular layering of pieces to create an uneven surface. This will provide great nooks and crannies to catch your paint.

3. Try to wrap the plaster strips around the edges of your canvas to create a seamless and unified sculptural quality to your canvas (fig. 3).

4. When the canvas is dry to the touch, begin working with watered-down layers of paint so that the pigment truly soaks into the plaster surface (fig. 4).

5. Slowly build up the opacity of your paint as the surface develops. Have fun with textural mark making and layering of colors (fig. 5).

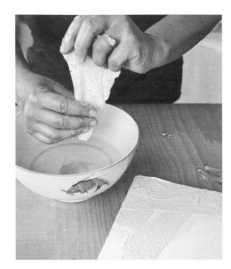

Fig. 2

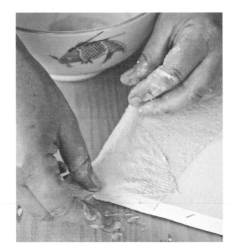

Fig. 3

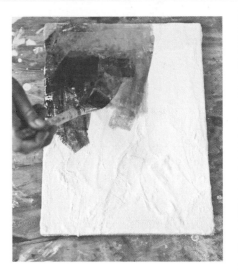

Fig. 4

Fig. 5

Painting on Metal

Aluminum flashing in the hardware store sparked the idea for this painting Lab. Luckily it comes thin enough so that you can cut it with scissors and easily hammer it onto wood. This technique is akin to inking up an etching plate, or you can paint more heavily onto it if desired. The metal lends an industrial sturdiness to the work that is a nice departure from a regular canvas texture.

- thin-gauge aluminum sheeting (used for chimney and roof flashing)
- wood surface, thicker than your nail lengths (1" [2.5 cm] plywood works great)
- heavy-duty metal cutting scissors
- white latex enamel paint
- various nail heads (such as carpet tacks and brads)
- hammer
- oil paint

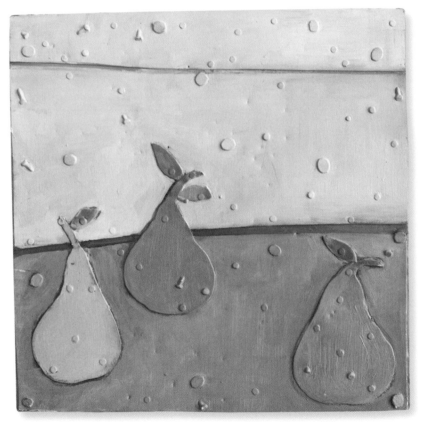

Above: *Pears*, oil and metal on panel

Top left: *Falling Bowls*, oil and metal on panel

Let's Go!

Fig. 1

Fig. 2

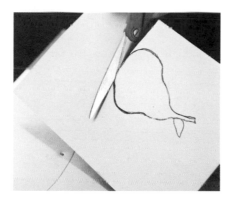
Fig. 3

Fig. 4

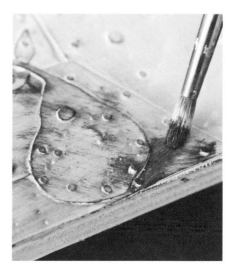
Fig. 5

1. After selecting your wood surface, start cutting, layering, and nailing the metal sheeting in various forms for the background (fig. 1).

2. Experiment with banging the nails sideways into the board as well as straight down. Try using the back of your hammer to dent and add texture to the metal (fig. 2). You can also use a metal brush to scuff the surface. Use different nail head sizes for shape interest.

3. Cut shapes from the metal to layer on this background (fig. 3). Once complete, prime the whole surface with white latex enamel paint (fig. 4).

4. Once the enamel is bone dry, begin to paint onto the surface and experiment with rubbing the paint over the texture to capture all of the nooks, crannies, bumps, and nicks on the surface (fig. 5).

Tips

- Be careful when working with thin metal sheets—the edges can be very sharp! Wear gloves when cutting.
- Hammering and nailing is a great way to add texture to the metal. The dents and nicks capture the paint beautifully.

Take It Further

Try applying the metal in a bent and curved fashion to create a semi-relief sculptural form in the piece.

Sgraffito:
Scratching the Surface

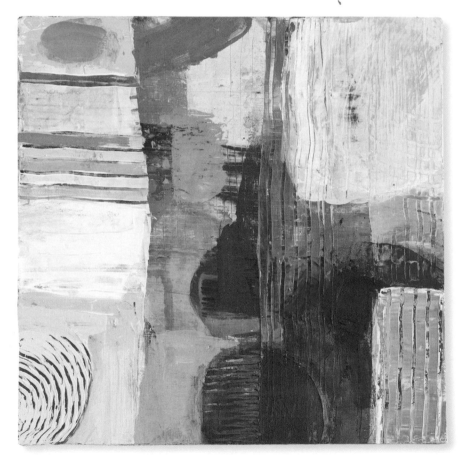

This exercise features another deductive painting technique, called *sgraffito*, which means "scratched" in Italian. To reveal the underlying layers in a painting, you can use two of the tools pictured here: a metal-toothed comb and a rubber-tipped stylus. These tools create beautiful texture and open up the exploration of unique linear elements in your painting.

- combing tool
- various rubber-tipped stylus tools
- transparent acrylic paints
- gel medium
- large palette knife
- acrylic retarder medium

"If it [dabbling in art] didn't amuse me, I beg you to believe that I wouldn't do it."

—Pierre-Auguste Renoir

Trails, acrylic on panel

Let's Go!

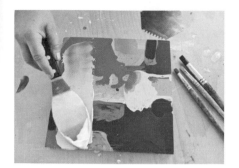

Fig. 1

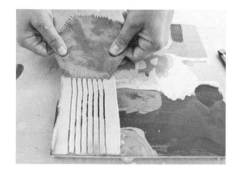

Fig. 2

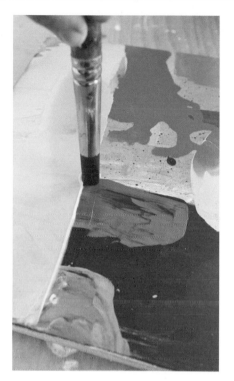

Fig. 3

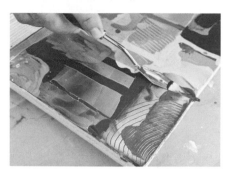

Fig. 4

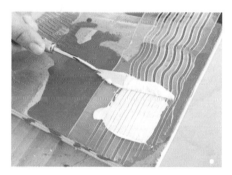

Fig. 5

1. Begin with a loosely painted and colorful underpainting to allow for an array of colors to be revealed.

2. Mix up a transparent color and some retarder to slow the drying time of your acrylic. This will allow for more open working time with your tools. Mix this with gel medium at a ratio of 1:5 chroma mixture to gel medium. Check the back of your paint labels to check for transparency.

3. Lay down the paint (fig. 1) and then drag the combing tool through this layer right away while the paint is wet (fig. 2).

4. Experiment with "drawing" using the rubber stylus tool for a more organic quality (fig. 3).

5. Layer additional transparent paint mixtures into the grooves of your sgraffito lines to create lush textures (figs. 4, 5).

Sgraffito

Sgraffito is a widely used technique found in ancient Greek ceramics to art nouveau facades. Twentieth-century artists such as Lari Pittman and Jean Dubuffet use *sgraffito* techniques as well.

The photocopy machine can contribute greatly to the content of your creations. The removed and degenerated quality of photocopies can provide an interesting juxtaposition to expressive color or gestural brushstrokes. And of course it opens up a plethora of imagery, which is easily added into your work. This Lab illustrates a simple method for transferring photocopied images onto your art.

- photocopied images
- acrylic gel medium
- any surface
- waxed paper
- smoothing tool

"You connect yourself to the viewer by sharing something that is inside of you that connects with something inside of him. All you have as your guide is that you know what moves you."

—Steven Brust

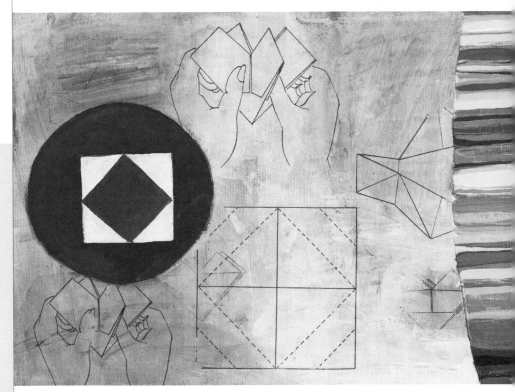

Fold, acrylic with copies of images on canvas

Let's Go!

Fig. 1

Fig. 2

Fig. 3

Fig. 4

Tips

- Use transparent paint mixtures to work into your painting to maintain the images.
- Once the image is transferred it will be reversed. If you want to use type, reverse it on your computer before printing and copying.
- Using colored images is not recommended.
- Paint with acrylic paint because oil paint will disrupt the image.

1. Select your photocopied image and trim the excess white around it so it is mostly image. Apply acrylic gel medium to coat the black-and-white image side (fig. 1) as well as the surface on which you will place it (fig. 2).

2. Place the photocopy image side down on your surface; do not put acrylic medium on the back of the image. Place some waxed paper on top of this and use a smoothing tool (here I am using a printing baren) to smooth down the image on the surface so that there are no wrinkles (fig. 3). When you are done smoothing, lift the waxed paper and let it dry.

3. Once the paper is completely dry, take a dab of water and swirl around on the backside of the image with your fingers to start removing the paper pulp (fig. 4). Keep doing this until no more paper fibers come off. Your image should now be transferred.

Materials

This project allows you to easily create a repeated motif in your painting with the use of a printing block. In your art supply store you can find extremely soft blocks that have the composition of a Pink Pearl eraser, and this makes for effortless cutting. The key to making this project work is to begin with an atmospheric ground underpainting, so the uppermost printing creates a frontal plane that increases the spatial depth of the overall piece.

- soft printing block
- lino carving tools
- water-based ink
- brayer roller
- plate for ink
- watercolor underpainting on paper or canvas

"Mystery is at the heart of creativity. That, and surprise."

—Julia Cameron

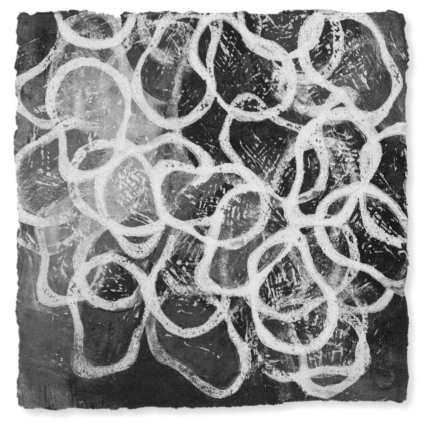

Loop, stamped print on gouache

Let's Go!

Fig. 1

Fig. 2

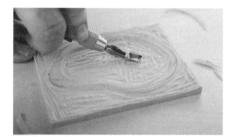

Fig. 3

1. Sketch out the form onto your printing block, and begin to carve (figs. 1, 2).
2. Keep carving until only your raised form remains; this is what will show up when printed (fig. 3).

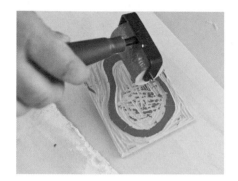

Fig. 4

3. Squeeze some water-based ink onto a plate and roll it out with a brayer. Roll the brayer to spread ink evenly onto your block (fig. 4).
4. Place the block on your painting and press down firmly to ensure a printed transfer. Make sure not to shift the block (fig. 5).
5. Carefully lift up the block and repeat to add more printed forms to the painting (fig. 6).

Fig. 5

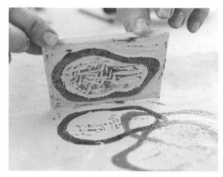

Fig. 6

More about Printing

I made the shape with the idea of an ear or a Munch skull-like shape, and I was excited to see the linear flow that was created when the forms were overlapped. It created a strange flower formation that was unexpected. Experiment on scratch paper to discover what your shape might create. Try two printings before re-inking the block for a ghosted image.

WHEN:
Capturing Time

4

UNIT

IN ESSENCE, a painting is a fixed and immoveable object. Yet, that does not mean that there cannot be a sense of time in a painting. In this unit we will explore the various ways that you can encompass a temporal influence in your work. Some examples include painting within a specific time frame to create a work such as the swing of a pendulum, or swift Zen brushstrokes. Other aspects of time in this unit embody creating a sense of movement, rhythm, and musicality through color interaction and flow. We will also explore the incorporation of rhythmic movement inspired by the imagery of the stop-motion photographer Eadweard Muybridge. Time is a rich subject matter in painting that can be investigated from multiple angles. Through a series of conceptual and technical strategies we will only scratch the surface of just how rich this topic can be in visual art.

Opposite: Harold Edgerton, Multiple-exposure photograph of pole vaulter John Uelses, 1964

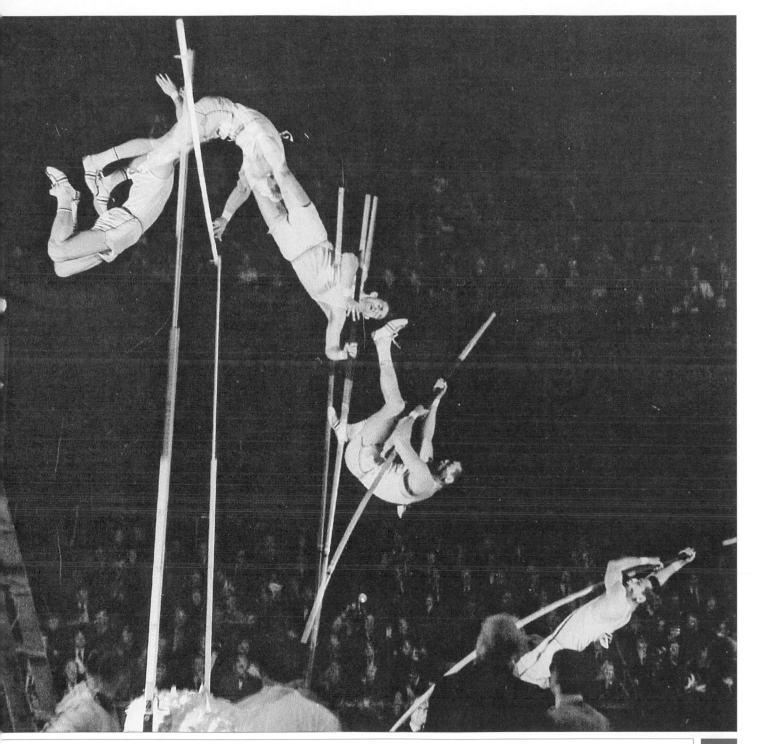

Seasonal Panorama:
A Color Journey

- acrylic paint
- heavyweight drawing paper
- glue stick
- scissors or craft knife
- 4" × 17" (10.2 × 43.2 cm) illustration board for mounting

This project is inspired by a classic Bauhaus color theory project of expressing the seasonal colors while exploring the muted and saturated potentiality of varying palettes. After painting a series of swatches, you will cut different-sized stripes to create a sequence of transition telling a story of the changing seasons.

Take It Further

- Which colors are more appealing to you? Do you use these colors often? Sometimes forcing yourself to use a different palette lets you discover more about color. Try using this new color scheme for an entire painting.
- Use the same complementary colors with a new wild card color.
- What other transitions could you explore? Perhaps a growth pattern or life cycle?

2-D design: winter to spring (top); summer to falll (middle); spring to summer (bottom), acrylic painted collage

Let's Go!

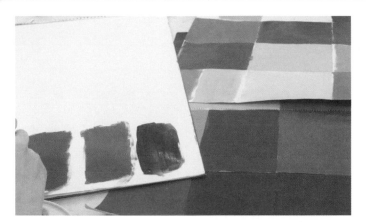

Fig. 1

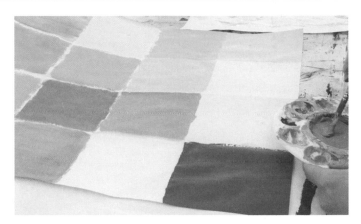

Fig. 2

1. To start, contemplate how you feel about the transition from one season to another. You can do some free-associative writing to help you form the content. The psychological profile of this writing will help you to select your palette.

2. Select your palette consisting of a set of complementary colors, plus a wild card and white (fig. 1). An example would be blue, orange, green, and white. By mixing your chosen paints, begin to unearth the variety of mixed colors in opaquely painted swatches on your drawing paper. Try to make those swatches at least 4" (10.2 cm) tall for cutting (fig. 2).

3. Once the swatches are dry, cut them up and sequence them to create the flow of the transitions (fig. 3). Mount the paper on illustration board with a glue stick (fig. 4). Let the color guide you!

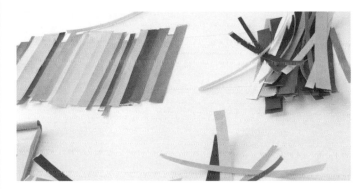

Fig. 3

Tips

- The color flow in this project can be inspired by literal aspects of the seasons such as sky and light, as well as with expressive symbolic color.

- Note on the back of the illustration board which colors were used as a reference for future work.

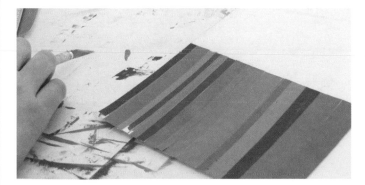

Fig. 4

26 Forms in Motion

- photocopies of Muybridge or Edgerton imagery (see sidebar)
- transfer paper
- any surface
- any paint

"The modern artist is working with space and time and expressing his feelings rather than illustrating."

—Jackson Pollock

A series of repetitive images similar to stop-motion photography can be an exciting way to bring rhythm, movement, and flow into your painting.

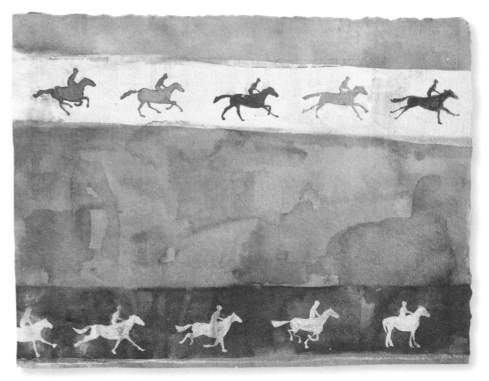

Trot, watercolor on paper

Let's Go!

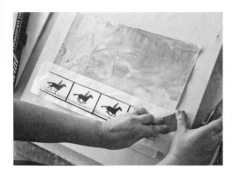

Fig. 1

Fig. 2

Fig. 3

Fig. 4

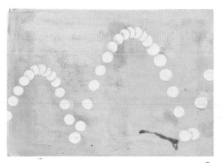

Fig. 5: Bounce, gouache on paper

1. Select an image that intrigues you—there is so much to choose from (fig. 1).

2. Create copies of this image and place them in your composition with the aid of the transfer paper to create movement in your piece (figs. 2, 3).

3. Approach the stop-motion images in simplified silhouetted form to enable you to transform the imagery with your own interplay and invention of color and design (figs. 4, 5).

Muybridge and Edgerton

Eadweard Muybridge was a British-born photographer who is famed for his groundbreaking images from the late 1800s that depict locomotion in stop-motion single frames. Harold Eugene "Doc" Edgerton, a professor of electrical engineering at the Massachusetts Institute of Technology, was the next photographic pioneer in this realm, who utilized the stroboscope as a device to capture imperceptible motion found in the flow of movement. (See www.edgerton-digital-collections.org and Muybridge's *Animals in Motion* CD-ROM and book published by Dover.)

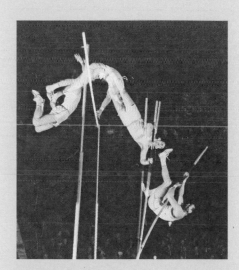

Detail, Harold Edgerton, Multiple-exposure photograph

Quick Gestures:
Working in a Series

- still-life setup or form
- diluted water-based paint (ink, acrylic, or watercolor will do)
- 6" × 8" (15.2 × 20.3 cm) pieces of watercolor paper
- brushes
- timer

"Don't paint bit by bit, but paint everything at once by placing tones everywhere … Use small brushstrokes and try to put down your perceptions immediately."

—Camille Pissarro

The painter Brice Hobbs was one of the most influential teachers I had at Rhode Island School of Design. In his class Direct Response to Form, the students worked from still life and the figure in quick gestural spurts. This is a fun and freeing exercise, and the results will surprise you!

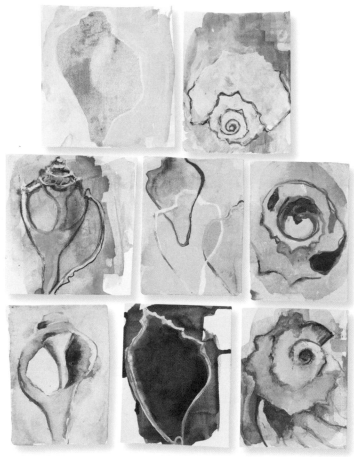

Multiple shell study, watercolor on paper

Let's Go!

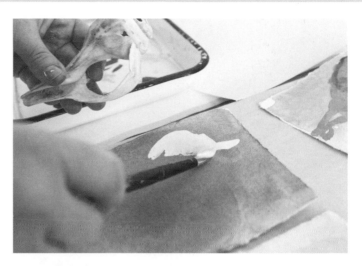

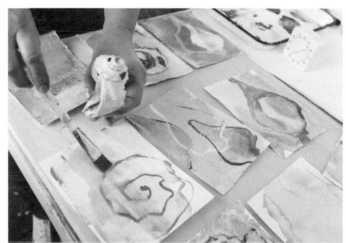

1. Cut up the watercolor paper, and arrange the pieces in a grouping of about five or seven on a surface.

2. Create your palette by choosing three or four colors diluted into washes and placed in cups. Try to include a warm and a cool tone to allow for shadow and highlight.

3. Set your timer for fifteen minutes.

4. Begin to respond to the still life, working simultaneously on all of your paper surfaces. See if you can get an image on all of your pieces in the fifteen minutes.

5. Explore your approach to imaging your form through silhouette, close-up, texture, multiple layering of forms, and beyond!

Take It Further

- In Brice Hobbs's class we would create ten pieces in the course of thirty minutes, which allotted about three minutes per piece.

- Try different color washes to get new effects or change the form you are observing.

- Take nine finished pieces that are your favorites and glue them with acrylic medium to a thicker board to create an interesting grid piece.

Featured Artist—Faith Evans-Sills:
Making Time

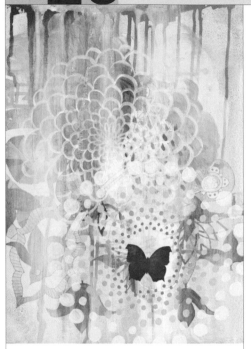

Artist Faith Evans-Sills feels that inspiration comes from anywhere and everywhere. For this exercise you will take pictures daily as a way of expanding your visual vocabulary, fine-tuning your observational skills, and reminding yourself of the beauty that lies all around even within your daily tasks. Evans-Sills uses variations on this exercise all the time to keep her senses awake, to prepare for her painting practice, and to feel most alive!

Above: *Quickening*, mixed media on canvas

Right: *Awakening*, mixed media on canvas

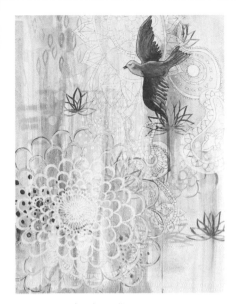

Dreamer, mixed media on canvas

Detail, *Angel*, mixed media on canvas

"As the mother of three young children, I have learned to say with confidence that becoming a mother taught me to be more truly myself than anything that I had experienced before. As a result, I make finding inspiration a daily practice so that when the moment is right for me to begin painting I am mentally ready to jump in.

"I have been required to weave my creative process into the very details of my life, keeping myself constantly inspired and ultimately appreciating life more as a result. My paintings are multilayered, reflecting the history of their making and their changing conditions over time. I paint through a slow buildup of directed process, adding layers as other layers dry, sometimes working in my studio but also being flexible enough to work at the kitchen table amidst the beautiful messy chaos of life. I usually begin with a bold wash of paint, followed by layers of drawing in pencil or pen directly onto the canvas. I finish each piece with other layers of painted images, birds, butterflies, and insects, bringing out the details that I feel are most important to voice the intent of each piece. I work to transform the public world of nature into a place of private knowledge. My paintings speak about the nuances of love, experience, and a personal mapping of the world."

(For more information on the artist, visit www.faithevanssills.com.)

Angel, mixed media on canvas

Pendulum Painting

Materials

- 8-oz paper cups
- string
- fluid acrylic
- large paper
- drop cloth

Inspired by John Cage (see sidebar), we will use a pendulum to harness a motion that is derived from external elements such as gravity and chance, rather than our control.

"On the floor I am more at ease. I feel nearer, more a part of the painting, since this way I can walk around it, work from the four sides, and literally be in the painting."

—Jackson Pollock

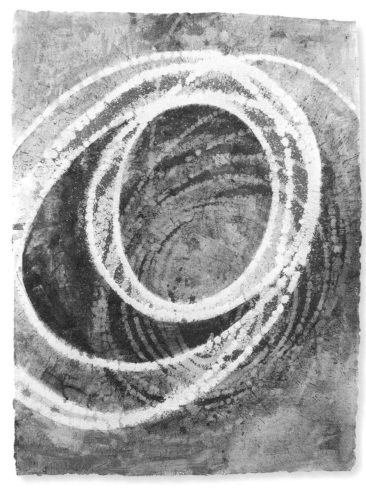

Spin, acrylic on paper

Let's Go!

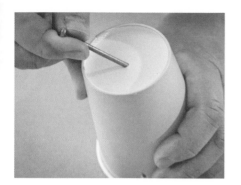

Fig. 1

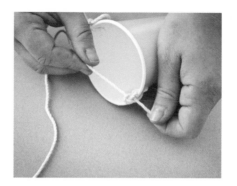

Fig. 2

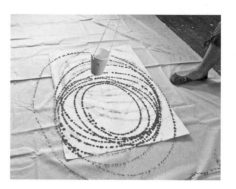

Fig. 4

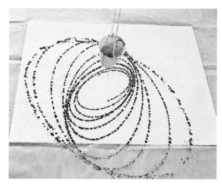

Fig. 3

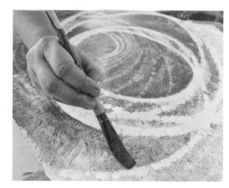

Fig. 5

1. Poke a hole in the middle of the bottom of a cup, plus two holes on the rim to attach the string handle (figs. 1, 2).

2. Place a piece of tape on the bottom of the hole, and then fill the cup with a mixture of fluid acrylic paint to water (about a 1:3 ratio). You want the consistency to be quite thin for proper flow.

3. Place a large drop cloth on the floor and then place a large piece of paper in the middle of the drop cloth.

4. Remove the tape and experiment with varying timed motions to create different patterns (fig. 3).

5. Once the painting is dry, layer more patterns by repeating this method (fig. 4).

6. When the entire piece is dry, experiment with painting into the piece with a transparent acrylic glaze to create depth and to highlight and edit the forms that interest you (fig. 5).

John Cage

The artist John Cage created a body of work that included both musical compositions and artwork. His main interest in these works was to remove the willfulness of his own hand and to instead harness and explore forces outside of himself. For example, he famously created a series of subway drawings in which his hand recorded with pen to paper the seismographic bumps of a subway traveling up and down the island of Manhattan (www.johncage.org).

Tempo Painting

In the spirit of Vasily Kandinsky, you will experiment with nonobjective painting as you paint to music. Let the sounds you hear inform your shapes and colors. This entertaining exercise allows great experimentation with the painting process.

- music
- paint
- canvas

"Do not fear mistakes—there are none."

—Miles Davis

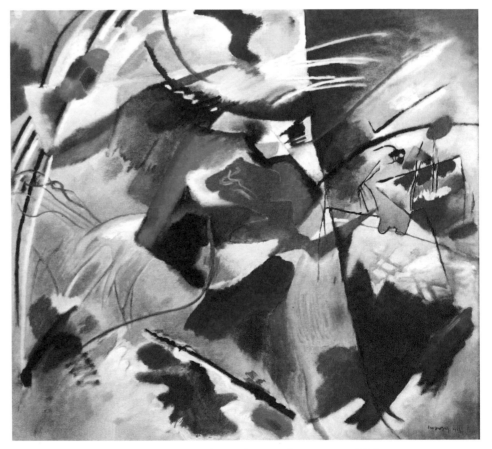

Above: Vasily Kandinsky, *Painting with Green Center*, oil on canvas, 1913

Top left: Yitong Cai, tempo study, oil on canvas

Let's Go!

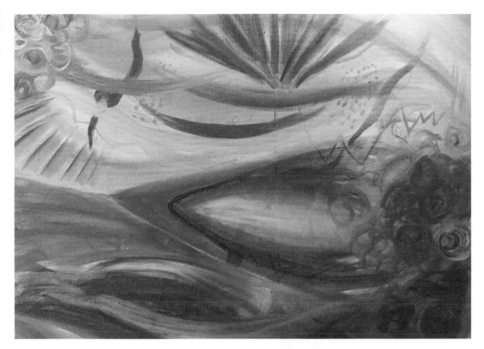

Above: Yitong Cai; **Below:** Amy Magaletti; tempo studies, oil on canvas

1. Select some music that is inspiring to you.
2. Try to respond to the rhythm of the music and the feeling of the sound through color and brushstroke.

Take It Further

Try this exercise again with another style of music. Also midpainting, flip your artwork upside down, or rotate it to get a fresh composition.

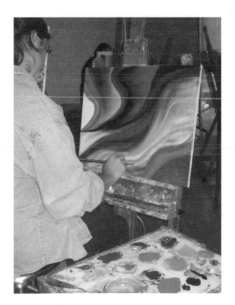

Vasily Kandinsky

The Russian-born painter Kandinsky was a pioneer artist in his creation of non-objective abstraction. This kind of abstraction is derived not from the forms of the observable world, but rather from forms that exist in the mind's eye. His greatest inspiration was music, in particular Tchaikovsky, which he vigorously painted to, responding to the crescendos and fluidity of the notes with brushstroke and color.

The term *synesthesia* refers to a neuro-logical condition where stimulation of one sensory pathway automatically triggers another, for example, not seeing color, but experiencing it with other senses. According to the *Telegraph* newspaper, the Kandinsky exhibition at the Tate Modern in London "shows how the artist used his synesthesia—the capacity to see sound and hear color—to create the world's first truly abstract paintings." Kandinsky apparently "recalled hearing a strange hissing noise when mixing colors in his paint box as a child" and later described the cello, which he played, as "one of the deepest blues of all instruments."

LAB 31

Metered Color:
Linear Rhythms

Materials

- wood support
- acrylic heavy gel medium
- acrylic glazing medium
- palette knife
- fluid acrylic paints
- rubber-tipped tool

"I do not try to dance better than anyone else. I only try to dance better than myself."

—Mikhail Baryshnikov

There are many relationships between music and art, and this project is about creating a rhythm with color, specifically with a stacked linear structure and layers of transparent and opaque acrylic paint. As you progressively build the painting, a metered rhythm will evolve from the color interaction and the proportion of chroma in the stripe sizes.

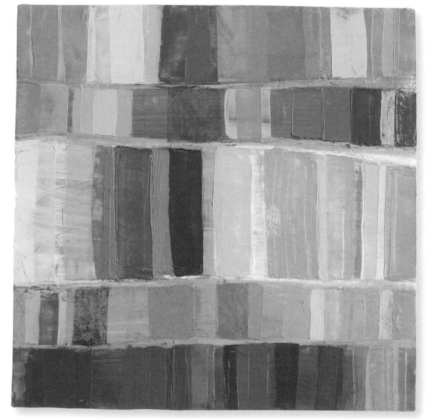

Bluestride, acrylic on panel

Let's Go!

Fig. 1

Fig. 2

Fig. 3

Fig. 4

1. Pare down your palette of fluid acrylics to three colors plus white.

2. Create the stacked lines for your composition.

3. Begin building on these long horizontals with mixtures of acrylic mixed with transparent mediums (figs. 1, 2).

4. The rubber-tipped tool can be a great tool for cleaning up the edges (fig. 3).

5. Keep building up the rhythms of stripes until a structure begins to evolve from the palette (fig. 4).

Tip

By using a limited palette in this project you will begin to understand the inevitable harmonies that will arise from the mixtures.

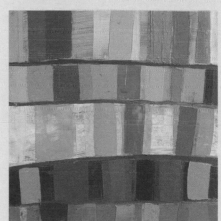

Pinky, acrylic on panel

Collaborative Zen Painting

- 18" × 24" (45.7 × 61 cm) or larger piece of watercolor paper
- large hake brushes (shown)
- watercolor or gouache paint
- tarp for floor
- large butcher tray for paints

For this lab, find two other people to paint with and, in the Zen tradition, be in the moment and create your marks 1, 2, 3!

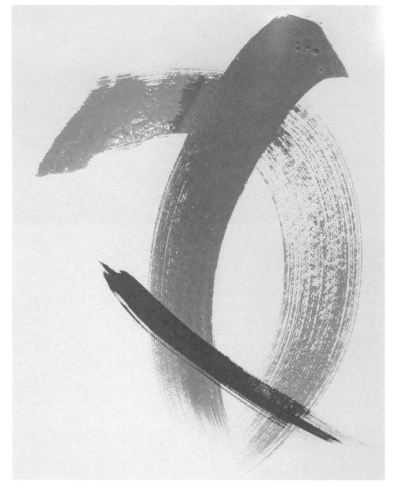

One, two, three, gouache on paper

"He neither serves nor rules, he transmits. His position is humble and the beauty at the crown is not his own. He is merely a channel."

—Paul Klee

Let's Go!

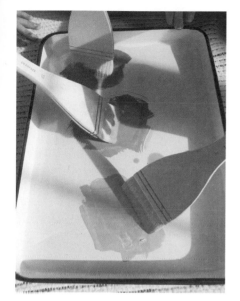

Fig. 1

Fig. 2

Fig. 3

This project is inspired by two art school experiences. The first experience occurred my freshman year in the dorms. Using leftover watercolor paint from a homework project, two friends and I created collaborative paintings that were composed of three deft brushstrokes. It was so much fun to paint in a social format and to create work that was fresh and spontaneous. The second experience was studying traditional calligraphy in Kyoto, Japan, where there exists an ancient and rich philosophy based on the energy and spontaneity of the mark. Simple marks can make a strong dramatic statement.

1. Pick two other collaborators who will bring enthusiasm to the project (our contributors Karina Holyoak Wood and her two daughters Ava and Maddy are shown at right).
2. Mix or place three colors onto the butcher tray, and add a little water to really load up each hake brush with pigment (fig. 1)
3. Place on the floor a tarp and on top of this the watercolor paper.
4. Take turns energetically painting the three marks. Let them overlap (figs. 2, 3).

Tip
Do three paintings using this process so each participant can have one.

WHERE:
A Sense of Place

IT IS OFTEN RECOMMENDED to beginning artists to travel the world for inspiration, and there is no denying that this kind of experience can generate a lot of ideas. The artist, Thomas Sgouros, whose eyesight was compromised late in life, traveled to limitless spaces in the realm of his imagination. So in this unit, we will do both: explore the internal and external landscape. We will go to the center of your home, and the center of your memory. We will journey to crumbling urban landscapes and idyllic ocean vistas. This unit includes an array of projects that have been created with a variety of concepts, materials, and techniques that will inspire you to create worlds of your own.

"Nature is not only all that is visible to the eye . . .
it also includes the inner pictures of the soul."
—Edvard Munch

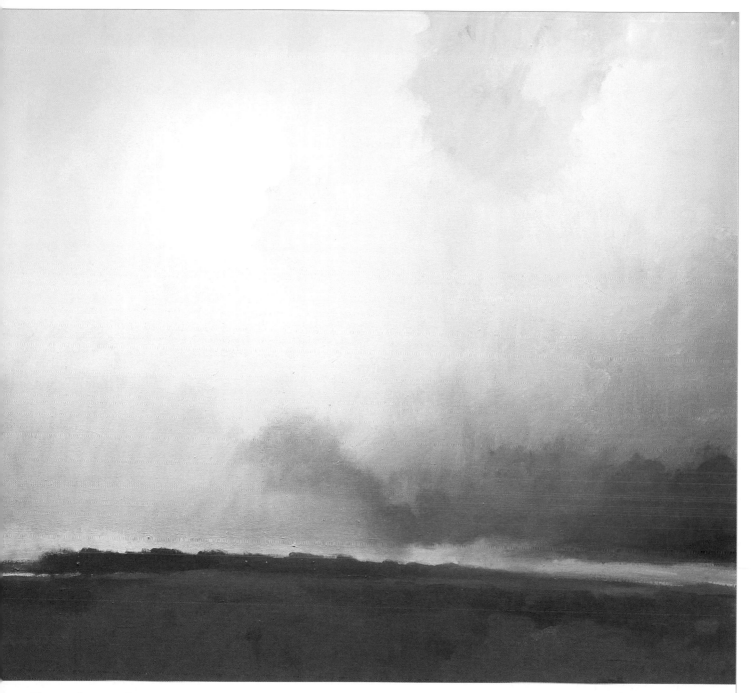

Thomas Sgouros, *Remembered Landscape 8 X 2011*, oil on linen, Courtesy of Private Collection and Cade Tompkins Project

Materials

- 1 or 2 sticks of vine charcoal
- 12" × 12" (30.5 × 30.5 cm) canvas
- acrylic paints: white, black, brown, yellow, red, and blue
- paint palette
- interesting dog photograph with clear facial features

"There isn't a single person or landscape or subject which doesn't possess some interest, although it may not be immediately apparent."

—Pierre-Auguste Renoir

Jennifer Bloom is a painter who specializes in painting portraits of the beloved pet. She creates beautiful paintings that capture the spirit of the animals through a combination of observation and a bold painterly hand.

Q: How did you get started in your focus on pet portraiture?

A: When I moved to Seattle I was struck at how dog-friendly the city was. There are tons of dog parks, dog spas, pet stores, canine activity outings in the parks. I am a big animal lover, especially of dogs and horses. I wanted to mix my love of painting and animals together.

Above: *Mouse,* acrylic on canvas; **Top left:** *Roosevelt,* acrylic on canvas
Opposite left: *Yorkie in a Floral Paradise,* acrylic on canvas
Opposite right: *Yellowish Yorkie,* acrylic on canvas

Q: What do you find inspiring about the subject matter?

A: Dogs have the most expressive faces with so many emotions. My goal on each portrait is to capture the personality of my subject, and leave my clients with a modern fine art painting.

Q: What are the challenges of pet portraiture?

A: It is important that the painting has all the elements that are important to me: a dancing composition, vivid color, pattern, humor, and the illusion of form.

Q: Tell me about the kinds of paints/tools that you use in your work.

A: I use acrylics, which are better for my health and the environment. I was trained as an oil painter, so I mimic that look with acrylics. I paint in the impasto style. No tricks or projecting the image beforehand are used. The palette knife and all shapes and sizes of brushes are utilized.

Q: How do you begin your process?

A: Before I start I really analyze the photograph and what the dog is saying within the composition and also as a dog.

Q: How do you know when a piece is finished?

A: The colors work in unison, the painting tells a story, and the dog comes alive.

Let's Go!

1. Choose a dog photograph. Divide it into four equal squares. Divide the canvas with charcoal into squares: two 3" (7.6 cm) horizontally and two 3" (7.6 cm) vertically. Look at the photograph and note what areas are in each box.

2. Squeeze the paints onto the palette. Make two or three grays, one or two browns, and some colors to pop your painting.

3. Really look at your photograph and ask yourself what makes this dog special. Does the dog have a smile? How about the hair texture? Is there a feeling in the eyes that you want to capture? Is the dog goofy or sweet, or both?

4. Make the background detailed or just a wash of color.

5. Begin to sketch on the canvas with the charcoal. Map out where your shapes will go and how they correspond to the photograph. Think of your painting as a whole image, not tiny little areas. Be expressive with the brushstrokes and color.

6. You can make the painting more detailed after starting this way. Remember, art should be fun!

This project combines the process of writing with the painting of a landscape that is more evocative than illustrative. Based on a drawing or a photograph, this endeavor generates an unpredicted connection between text and a sense of place.

- acrylic gel medium
- photograph or drawing of a landscape for inspiration
- permanent pens (such as Sharpies)
- 18" × 24" (45.7 × 61 cm) drawing paper
- acrylic or oil paints
- primed canvas

"I begin with an idea and then it becomes something else."
—Pablo Picasso

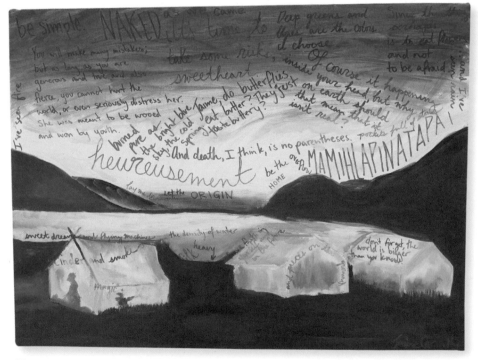

Above: Jaime Carvalho, *Night Study*, paper collage with oil on canvas

Top left: Jennifer Sands, *Maine*, paper collage and oil on canvas

Let's Go!

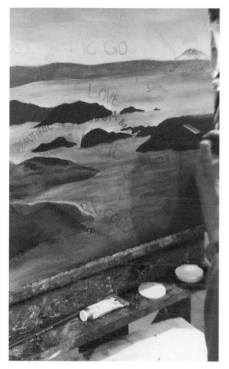

Fig. 1: Jennifer Sands, *Maine*, paper collage and oil on canvas

Fig. 2: Yitong Cai, lettering collage

Fig. 3: Yitong Cai, lettering collage

Fig. 4: Zimbiri Zimbiri, tree study, paper collage and oil on canvas

1. Select a drawing or a photograph that depicts a landscape that has relevance to you (fig. 1).
2. Begin by creating on a piece of paper a free association of words or phrases that are based on the set landscape.
3. Now begin to tear the words from the paper, crumple some, and collage it upon a pre-primed canvas using acrylic gel medium as your glue. The crumpling will provide an interesting texture in your ground (figs. 2, 3).
4. Once the collage has dried, begin painting onto this ground all the while being mindful of using transparent washes where you want to maintain the perception of the text (fig. 4).

Take It Further

Try painting some words and thoughts as well as adding them with the torn papers. You could also incorporate found paper in this project to relate to the chosen landscape, such as old letters or maps.

Waterworks:
Painting by the Sea

- portable watercolor paints
- small piece of watercolor paper
- brushes
- small water container

"If at first you don't succeed, try, try, again."

—Thomas H. Palmer

This is an interesting exercise because it forces you to embody the feeling of water through gesture rather than photorealistic accuracy because the water is constantly moving. The example shown here was created on beautiful Block Island in Rhode Island, where the pristine seashore provides endless inspiration and beauty.

Above: Motion study #2, watercolor on paper

Top left: Motion study #1, watercolor on paper

Let's Go!

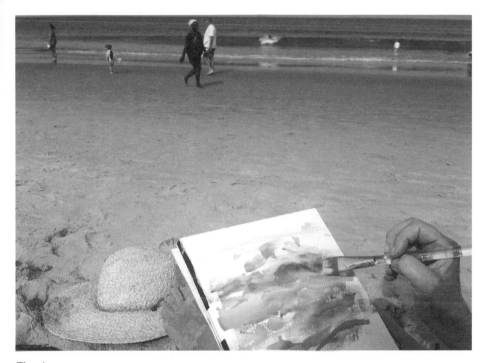

Fig. 1

1. Find a location that has a constantly moving element. This can be water, clouds, and so on.

2. Pack a very portable setup of materials that you can fit in a small bag for easy travel.

3. Observe your landscape choice and then begin to coordinate your movements of the brushstrokes with the movement of the forms (fig. 1).

4. Keep the colors simple, and experiment with the layering of the marks and colors until you reach the desired effect (fig. 2).

Fig. 2

On-the-Go Painting

For painting on location keep your materials lightweight and basic. Don't forget a hat, sunscreen, perhaps some bug spray, and something to drink.

Take It Further

Try incorporating an overlay of stop-motion imagery on top of this painting to create another veil of movement that begins to juxtapose the landscape (see "Lab 26").

"Color is the language of the listening eye." —Paul Gauguin

Thomas Sgouros's series of paintings entitled *Remembered Landscape* began in early 1990 out of a deep dedication to painting and a willingness to change in the midst of an illustrious career established in realism. Having a career as a painter of finely defined but painterly still-life works, Sgouros was stricken with the sudden onset of macular degeneration and began to lose his eyesight. In his own words, "It was either jump in the river or rethink the way I was going to paint." The paintings are at once luminist, expressive, and modern. The artist remembered visions of light, reflection, and atmosphere, all of which come to life on canvas, much like the abstracted paintings of J. M. W. Turner (English 1775–1851). Painterly tones of rich reds, oranges, whites, and blues juxtaposed with darker earth colors of browns and greens all allude to the landscape. Sgouros's career panned more than fifty-six years, as a renowned illustrator in his early career to a distinguished painter of sublime watercolors and still-life canvases in his later career. Sgouros was a professor emeritus of the Rhode Island School of Design and recipient of numerous prestigious awards, such as the Pell Award for the Arts—Text courtesy of the Cade Tompkins Project.

Opposite: *Thomas Sgouros, Remembered Landscape 6 XI 09, oil on linen, Courtesy of Cade Tompkins Project*

Above right: *Thomas Sgouros, Remembered Landscape 7 III 08, oil on linen, Courtesy of the artist and Cade Tompkins Project*

Below right: *Thomas Sgouros, Remembered Landscape 26 VII 09, oil on linen, Courtesy of Cade Tompkins Project*

Let's Go!

Try remembering a place you've been and re-creating your mind's view on canvas.

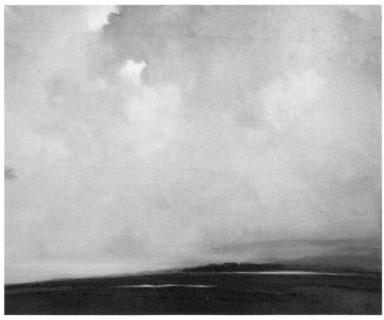

Materials

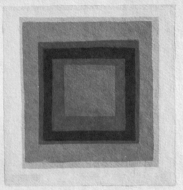

- gouache paint
 (best for its rich pigment)
- watercolor paper
- ruler
- pencil

"No one ever discovered anything new by coloring inside the lines."

—Thomas Vaquez

In the spirit of Josef Albers, try experimenting with a geometric scheme, depending entirely on color relationships and quantities, to evoke your own sense of place.

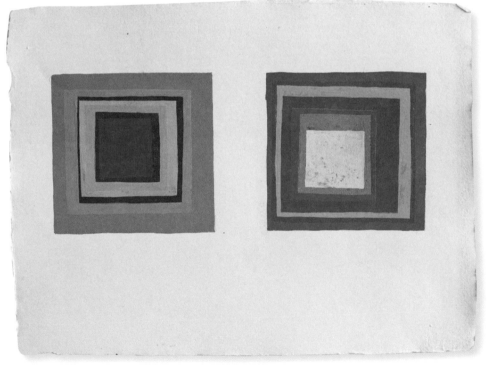

Above: *Times Square*, gouache on paper
Top left: *Falmouth in November*, gouache on paper

Let's Go!

Fig. 1

1. First think about the place that you would like to evoke by writing about it in a free-associative way and then pulling colors that correlate with this writing (fig. 1). The places I am depicting here are the organic, oceanic tones of Falmouth, Massachusetts, beaches in the winter (opposite page, top). The double image is inspired by the garish illumination of Times Square in New York (opposite page, bottom).

2. With a pencil and ruler, create a square on your watercolor paper (fig. 2).

3. Begin to lay down your nested squares or rectangles of color (figs. 3, 4). Just be sure that the top and side edges remain parallel. You can go back and add colors as needed. Experiment with getting your composed squares or rectangles to radiate or contract, or a little bit of both.

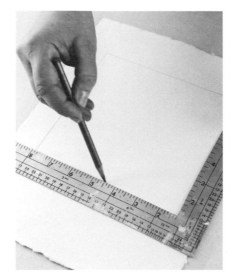

Fig. 2

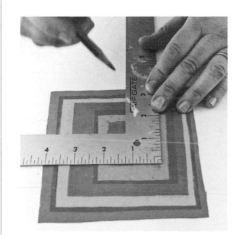

Fig. 3

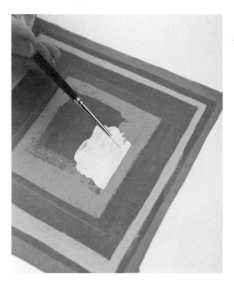

Fig. 4

Josef Albers

This project is inspired by the work of Albers, who is known as the father of color theory. His body of work called the *Homage to the Square* reflected his fascination and devotion to color as he repeatedly used the image of nested squares to explore the poetics of color interaction. Many of these works are cryptically titled in reference to a specific place.

Take It Further

Try this exercise again with another geometric form.

38

Featured Artist—Neal T. Walsh:
The Weathered Wall

Neal T. Walsh is a painter from Providence, Rhode Island, who finds inspiration in the layers and patina of the city surrounding him. He uses some interesting techniques to build up the rich, evocative surfaces of his paintings.

- canvas or watercolor paper (gessoed or sized, and with background painted)
- paper such as art papers, found paper, or old books
- archival adhesive such as PVA (polyvinyl-acetate) or water-based gel medium
- sandpaper (optional)
- water-based paint (or oil paint if paper is sized)

Above: *The Clearing*, oil, ash, mixed media on panel

Right: *Convalescence*, oil and mixed media, recycled canvas on prepared paper

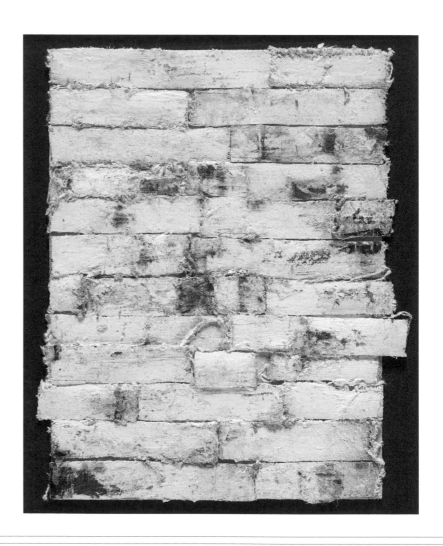

Detail, *Twilight Skylark*, oil and collage

Q: Discuss the relevance of decay and ruin in your work.

A: Ruin and decay have played an important role in how I have thought about my paintings. I began painting in earnest in an old mill building, surrounded by other relics of the New England industrial revolution. I lived on the fourth floor of a building that overlooked a steelyard, a river, vacant lots, and other old mill buildings that were slowly falling into ruins. I walked and biked along the river and railroad tracks and explored old abandoned factories: the fading paint on signs and doors, the light on the old brick surfaces, the green riot of overgrown weeds and plants, the weeping rust of forgotten machinery, the shattered and patched grids of abandoned factory windows, an autumn blue sky through cracked walls. All these elements worked their way into my paintings.

Q: Do you include found materials in your paintings, or employ certain processes to create the effects of your surfaces? How is this combined with the paint?

A: I wanted to create dense textural paintings that had a physical presence. I began by using random bits collected from the studio floor: old painting rags, newspaper, and cardboard. I experimented with a variety of adhesive tapes and weathered pages from found books. I liked the patina of the paper and the hint of text that sometimes bled through the layers of paint. Fragments of visible text were incorporated in naming the painting. The adhesive tape or torn pages are applied to the support and are worked into with more layers of paint alternating with scraping, scratching, sanding, and burning till the paintings achieve a balance between what is revealed and what is hidden.

Let's Go!

Experimenting with found paper or art paper, create a collage by layering on a prepared support. If you desire, try painting some papers before adding them to your collage.

1. Collage paper onto the surface, and then rip away parts of the collaged paper to expose layers underneath.

2. Use thin layers of glue or gel spread evenly across the paper to yield a smooth surface and fewer wrinkles.

3. Add paint layers, and when dry work into the paint using sandpaper or scrapers to pull away portions and expose the base.

4. Add and subtract until you create something you like.

- pencil
- paper
- water-based paint
- small brushes

"Nonjudgment quiets the internal dialogue, and this opens once again the doorway to creativity."

—Deepak Chopra

It is common advice to tell beginning students to avoid placing form in the center of the picture as this can cause a static nonmoving effect. Yet, there are times when you desire to create an image where your eye can gaze peacefully. Creating a mandala painting is the perfect opportunity to play with symmetry and centeredness as a motif. Working this way is a path to quieting and calming your overall sense of self.

Above: Mandala study #2, gouache and watercolor on paper

Top left: Mandala study #1, gouache and watercolor on paper

Let's Go!

Fig. 1

Fig. 2

Fig. 3

Fig. 4

1. Find a sunny and pleasant tabletop working space.

2. On a square piece of paper, estimate (no rulers) the center of the paper and begin to draw your first central shape. Do not predetermine this shape; let spontaneity guide you in choosing this form (fig. 1).

3. Choose a limited palette of three or four colors and create a painting from mixtures of these so that your color remains harmonious and not too busy (fig. 2).

4. Alternate forms on opposite sides of the central image to create an axis of symmetry (fig. 3).

5. Keep building this fanning out of forms until you feel that the overall form fills the page in a pleasing way (fig. 4).

Yantras

Similar to mandalas, yantras are two-dimensional and also geometric and circular in form. They are intended as talismans and charms to ward off obstacles and demons, and to bring good fortune, power, a rich harvest, abundance of wealth, and happiness.

Featured Artist—Alyn Carlson:
Landscapes in flux

Let's Go!

Go for a walk through a favorite place and create ten quick sketches in a sketchbook. When you are back in the studio, see if you can combine three of the sketches into one image. Let the process and color guide you.

Alyn Carlson is a painter working out of Westport, Massachusetts, a pastoral slice of coastal New England. She follows a nontraditional approach to the landscape genre.

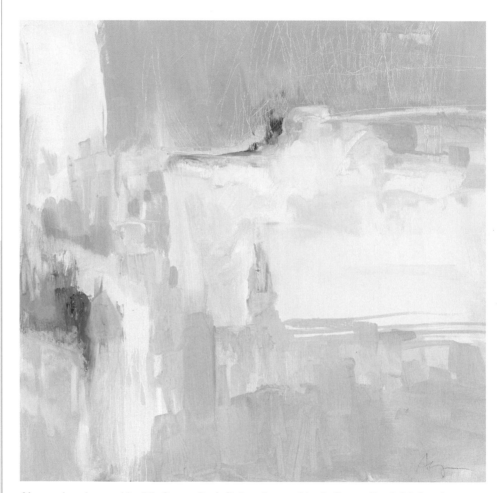

"One of my favorite things to do is put down a combination I feel may not be beautiful and see what can come from that. Some of my best pieces have started there."

—Alyn Carlson

Above: *Landscape No. 23*; **Opposite left:** *Landscape No. 8*; **Opposite right:** *Landscape No. 16* (all poppyseed oil paint, oil bar, and graphite on gessoed birch plywood)

Q: Do you work from life, a memory, or photography to begin an image?

A: I don't work from life, but I practice particular types of observations that inform my work. For over thirty years I've walked and absorbed the same landscape that I deeply love. I live at the beginning of the Cape in a town that's sixty-four square miles of farmland with two branches of a river that wind through marshes and estuaries, and end at Buzzards Bay. I walk and observe more in the winter and fall when the skeleton of the land is more evident. I spend a lot of time looking at both the larger sweeps of landscape and tiny intimate bits and parts. I try not to search and record as much as just absorb. I like what I'm seeing to leak in through my pores. I may not be seeing the color that will eventually come out in the painting, but what I'm feeling about the landscape will be translated into color. Color to me is emotion and can be much larger than the representational palette we see in New England.

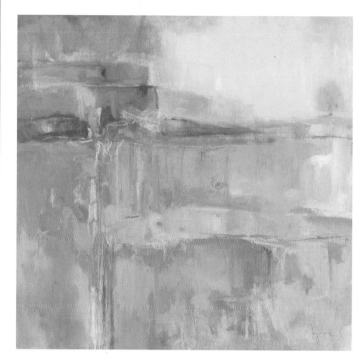

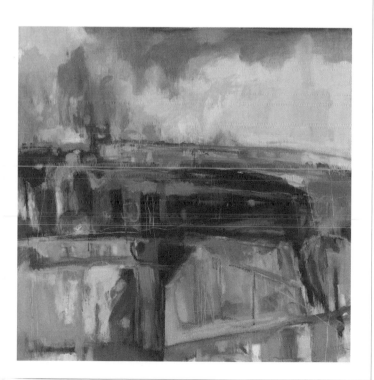

Q: Discuss your process with the materials/color. What are you using, and how are you using them?

A: My oil paints are Charvin poppy seed paints and Sennelier oil sticks. I use poppy seed oil as a medium and sometimes a little Japan drier. Because the pigment is so intense with these paints, I can often start with rubbing or staining the surface first. I work very quickly for the first three-fourths of the painting, which keeps me away from too much analytical thinking. I usually work color plane against color for quite a while before I introduce line. The painting is the most malleable before I incorporate drawing, so I often wait till the painting is almost complete to add it. I prefer working on gessoed birch plywood rather than stretched canvas. On plywood there is less absorption of pigment and it takes scratched or applied line well.

Featured Artist—Patty Stone:
Aerial Views

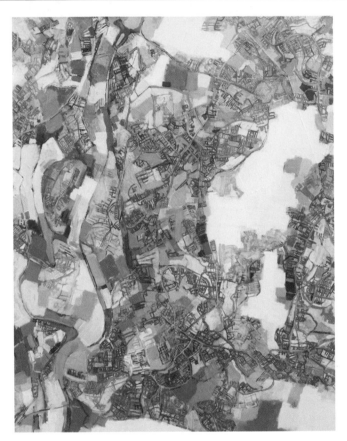

Charles River White, collage, oil on canvas

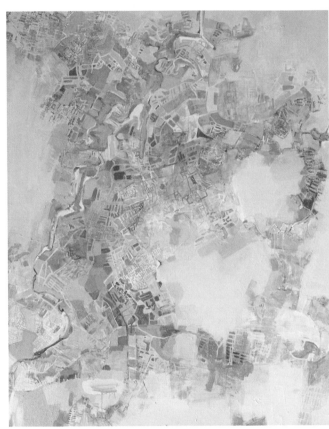

Charles River Yellow, collage, oil on canvas

"Every artist dips his brush in his own soul and paints his own nature into his pictures."

—Henry Ward Beecher

Patty Stone is a Boston-area artist. Her work incorporates an aerial perspective that plays with spatial elements and a rich painterly surface.

Q: Discuss relevance of perspective and sense of place in your art.

A: My paintings are inspired by places that are personally significant: my suburban neighborhood, the Southwest where I grew up, or the Charles River where I walk almost every day. The paintings form a personal diary. These places exist in the physical world but carry meaning through experience. Here landscape and memory combine to create images that are freely interpreted.

Q: How do the materials relate to the content and meaning?

A: I use many different kinds of maps as source material, changing scale and perspective. I combine snapshots of street views with pieces of road maps or other elements of collage. Recent monotypes have focused on the Charles River and invasive plant species. I suggest a muddy river bottom through organic patterns and layered washes that create the illusion of transparency. These materials create a deeper space within the flat color shapes and energize the composition with multiple viewpoints.

A painting can start from a color, a line, or a shape on a map. I need a personal connection to the location as a point of departure but once a painting is under way, the formal elements of drawing and design take over. I do a few line drawings first to work out the basic pattern, but most of the discovery happens later, within the paint.

Let's Go!

Draw or paint a location from three different viewpoints, each on a separate sheet of paper. Choose some details—close up views or distant views from above or below. Combine elements of the three views into one image using collage, drawing, and painting. Cut up two of the drawings into squares or rectangles and paste them onto the third image, using it as a ground layer. Look for connected lines and rhythms.

Invasive Species, intaglio and monotype on paper

High-Tech Sketchbook

Materials

- smartphone with sketching app (Rebecca uses Doodle Buddy)

Rebecca Jenness is an artist living in Providence, Rhode Island, who uses technology to help form her art. Observations are recorded by hand sketching on an iPhone when weather or site location, such as rooftops and abandoned structures, make traditional materials difficult to use. Rebecca's work is a good example of using a digital tool to ultimately create something hand made!

Rebecca Jenness

Rebecca takes much of her inspiration from the city that surrounds her. "My work has been concentrated on the content of cityscapes, skyscraper nests, hot summer sidewalks, and the colors of brick and steel structures. My awareness is that of the combined reference of nature and human composition collected in the city's architecture."

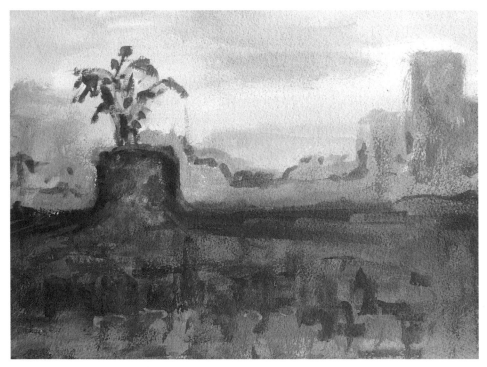

Rebecca Jenness, *Against the Odds*, acrylic gouache on paper

Let's Go!

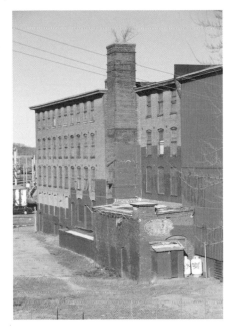

Fig. 1

1. When in a situation where paper and art-materials sketching is not possible, use the drawing app to get a feeling for a composition and color. You can easily make many of these sketches to refer to later for inspiration (fig. 1).

2. Once you are back in your studio, reference your digital imagery to then begin handmade thumbnails and eventually a finished piece (fig. 2)!

Fig. 2

Tip

I recommend that my students keep a sketchbook. Sketchbooks are extremely important and useful for documenting ideas on the go. These unformulated ideas can then be used to hone an image in the studio. They should be portable and nonprecious. A nice aspect of the phone sketches is that they can be downloaded to your computer and saved for later use.

HOW:
Finessing Your
Color Craft

THE BAUHAUS was a groundbreaking school in early twentieth-century Germany that created a new method to teach color. In this school, from the teachings of Itten, Klee, Kandinsky, and especially Josef Albers, color was taught as not just a means to render form and space: Color became the subject in its own right. Color theory, as it is known, also addressed the phenomenon of interaction and the potential of color's expressive and psychological properties. These methods have had a great influence on my own work and approach to teaching this subject matter. Through my years in the classroom, I have come to believe that people carry within themselves an intuitive sense of color, yet through the acquisition of basic color theory this natural sensibility becomes honed and articulated. It is important to have a basic understanding of color theory, for it is the foundation of painting. And because of this, the projects in this chapter can be woven into all of the Labs in this book. In this chapter, we will investigate the basics of color in terms of hue, value, and intensity. We will explore the limitless communicative power of chroma, from the dynamism of complementary colors, to the subtle beauty of chromatic grays, and more.

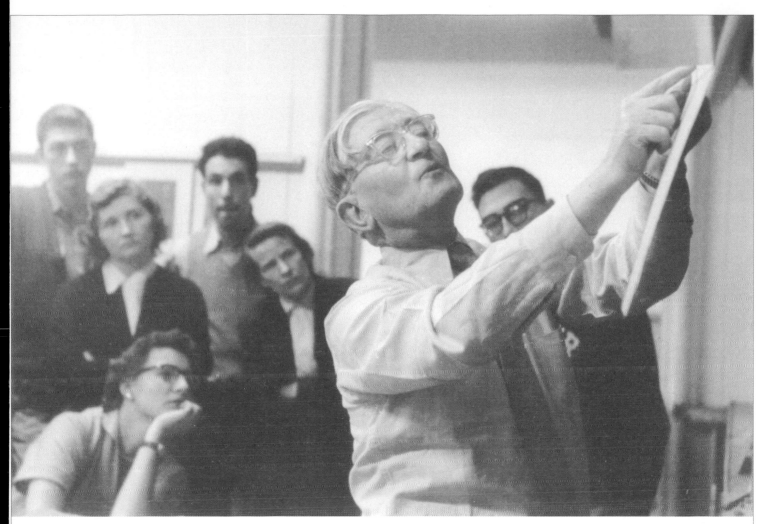

Josef Albers teaching in the classroom

"In my basic courses I have always tried to develop discovery and invention, which in my opinion, are the criteria of creativeness."

—Josef Albers

Value in Grays:
Lyrical Abstraction

A good place to begin to understand color is surprisingly by working with a gray scale made from black and white. This will hone your eye to look for a value range of lightness and darkness. The inclusion of this full range will bring a sparkling graphic quality to your painting, and it will ultimately help you to see the value range in your colors as well.

In this project my students developed their black-and-white painting from a cut paper collage. They did not have to copy the original collage to a tee, but rather use it as a springboard to generate an interesting painting. The abstract nature of this painting helps to really focus on the range of grays that are used, a complete range of values from light to dark.

- ivory black (oil, acrylic, or gouache)
- titanium white (oil, acrylic, or gouache)
- canvas
- coilage (optional)
- palette paper
- palette knife
- acrylic gel medium

"What I give form to in daylight is only one percent of what I have seen in darkness."

—M. C. Escher

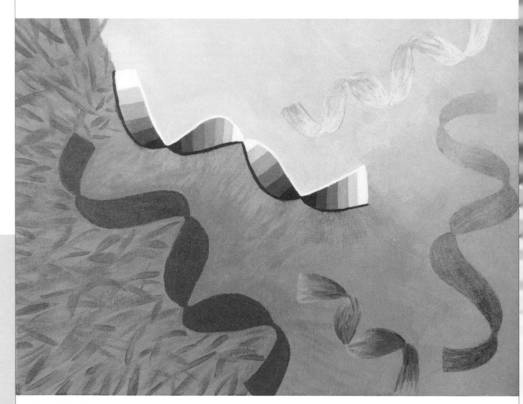

Sarah Redlich, value study, acrylic on canvas

Let's Go!

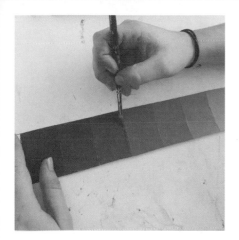

Fig. 1

1. Create an eleven-step gray scale using the black and white paint, starting with pure black on one end, and ending with white on the other (fig. 1).

2. You can choose to work from a collage (fig. 2) or sketch some forms directly onto your canvas (fig. 3).

3. Begin to paint on your canvas and let the painting guide you; maybe some forms stay and some get added along the way (fig. 4). Try to distribute a complete gray scale from light to dark in a lyrical way (fig. 5).

4. Try incorporating acrylic gel medium into your grays on the uppermost layers of your canvas to achieve a depth and translucent veils of space in your painted surface (see "Lab 51").

Fig. 2: Paris Dowd, construction paper and acrylic on canvas

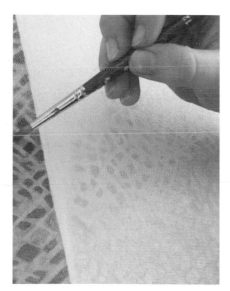

Fig. 3

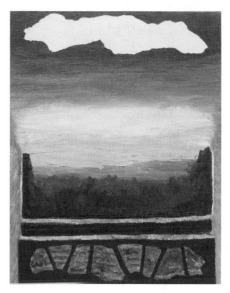

Fig. 4: Paris Dowd, construction paper and acrylic on canvas

Fig. 5: Leah Smith, value study, acrylic on canvas

LAB 44 Monochromatic Still Life

Materials

- a darkly pigmented paint
- titanium white paint
- heavyweight paper
- simple still life
- desk lamp for single dramatic light source

Picasso went through a blue period, and here is your chance to go through a color era of your own. A monochromatic palette has just one color, plus white for tinting. This is a great way to practice developing a full value range, and there is a quiet elegance that arises as you depict a simple form on a white surface dealing with depth, highlight, and shadow.

"Twenty years from now you will be more disappointed by the things that you didn't do than by the ones you did do. So throw off the bowlines. Sail away from the safe harbor. Catch the trade winds in your sails. Explore. Dream. Discover."

—Mark Twain

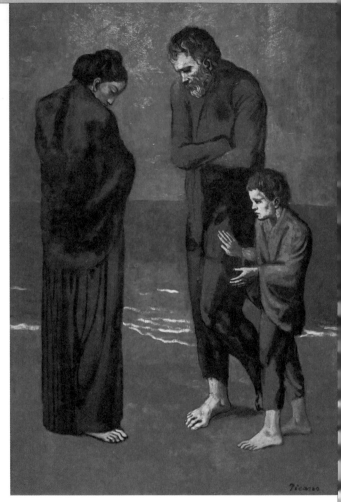

Pablo Picasso, *The Tragedy*, oil on wood, 1903

Let's Go!

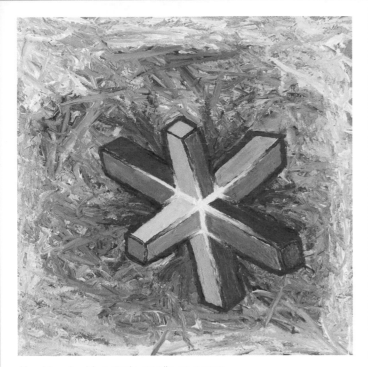

Alec Horwitz, blue study, acrylic on paper

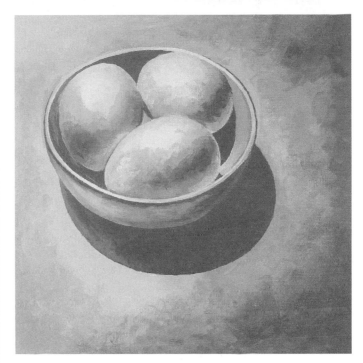

Sandra Cordtz, yellow ochre eggs study, acrylic on paper

Fig. 1

1. Select your color that you will mix with white. Good choices tend to be dark out of the tube so that you have a lot of range in your value such as blues, reds, and earth tones.

2. Create a seven-step scale (7" × 1½" [17.8 × 3.8 cm]) from light to dark so that you can begin to control the value range available (fig. 1).

3. Set up a single dramatic lighting source in a dark room so that the shadows and highlights are exaggerated in the still-life scene. Begin to plug in the darkest values for the deep shadows and the tints for the highlights.

Take It Further

Try it again with another color.

Painting with Shades

- black paint
- white paint
- three primary colors of any paint
- pencil
- canvas or watercolor paper

A hallmark of mixing black into your palette is that, because black absorbs light rather than reflects it, it mutes the intensity of your color palette. Begin with small amounts of black, and be mindful of the mutedness by including pops of pure color.

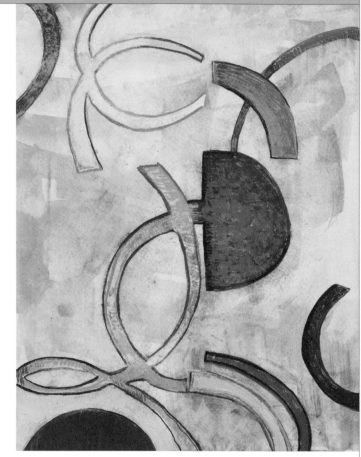

Shaded Vines, watercolor and gouache on paper

"In all matters of creativity, rules are meant to be broken when necessary."

—Haley Langford

Max Beckmann

Beckmann is an artist who used shades beautifully to create drama and heft in his expressionistic and narrative paintings.

Let's Go!

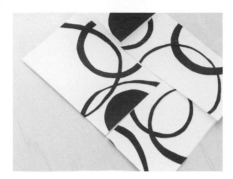

Fig. 1

Fig. 2

1. Create your composition in pencil on the surface. The sample features a cut paper design from Lab 5 (fig. 1).

2. Experiment on scratch paper to see the effect of the black in your primary colors (fig. 2).

3. Tint these shaded mixtures with white to create a variety of light and dark colors in your painting (fig. 3). Enhance dulled areas with pure color (fig. 4). Paint away!

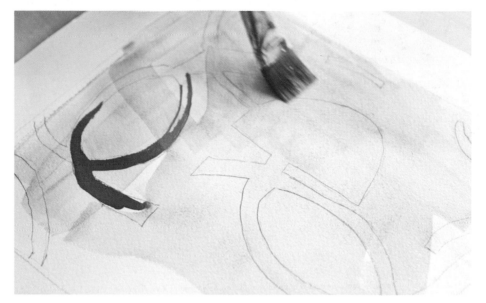

Fig. 3

Fig. 4

Tip

Adding black to your palette can create some interesting effects. Black transforms yellows into tones of green, ranging from chartreuse to olive, and it brings the maroon out of a red.

Materials

Here is an exercise in limitations, because your palette will consist of only two primary colors, from which only analogous colors can be created. This creates a fun challenge because there is no white to create highlights, and it forces your hand to create highlight and shadow with intense color, which ultimately creates a richer painting.

- two primary colors (pick two: cadmium red medium hue, cadmium yellow medium hue, ultramarine blue)
- palette knife
- heavyweight drawing paper
- palette paper
- simple still life
- acrylic gel medium

"Others have seen what is and asked why. I have seen what could be and asked why not."

—Pablo Picasso

Vincent van Gogh, *Sunflowers*, oil on canvas, 1889

Let's Go!

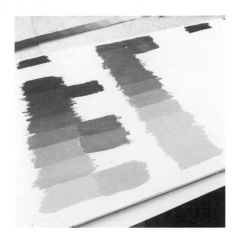

Fig. 1

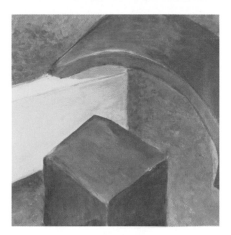

Fig. 2: Lindsey Gillis, blue/green study, acrylic on paper

Tip

Analogous colors lie next to each other on the color wheel. From your two primary colors you will create your other colors: red and yellow to make orange, blue and red to make violet, and blue and yellow to make green. Notice how these secondary colors are different from the same paints dispensed from a tube or pan of watercolors.

1. Choose two primary colors and create an eleven-stop scale with the pure primaries on either side of the scale (fig. 1). You should achieve a mixed secondary hue in the center of the scale as you balance these two colors.

2. Once you are done with your scale, choose a simple still life. Here my students are working with children's building blocks (fig. 2). These relatively simple forms are perfect to focus on basic shadow and highlight relationships.

3. Create a 10" × 10" (25.4 × 25.4 cm) area on your heavyweight paper and begin to paint with this palette. You can draw out the forms first if you wish. Use warm colors for highlights, and cool colors for shadow (fig. 3).

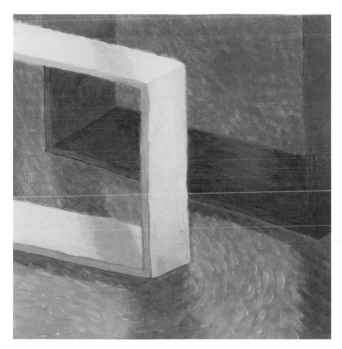

Fig. 3: Leah Smith, analogous study, acrylic on paper

47

Complementary Colors:
Red and Green

- middle green
 (acrylic or gouache)
- cadmium red medium hue
 (acrylic or gouache)
- heavyweight drawing paper
- palette knife

"Marrying a shade of green to a red, one can either sadden a cheek or make it smile."

—Paul Cézanne

This duo of complements has deep associations to Christmas, but do not let that dissuade you from experimenting with this combination of complementary colors. When mixed together, red and green yield beautiful cool granite-like grays that can be interesting to work with, especially when accented with a pop of pure red.

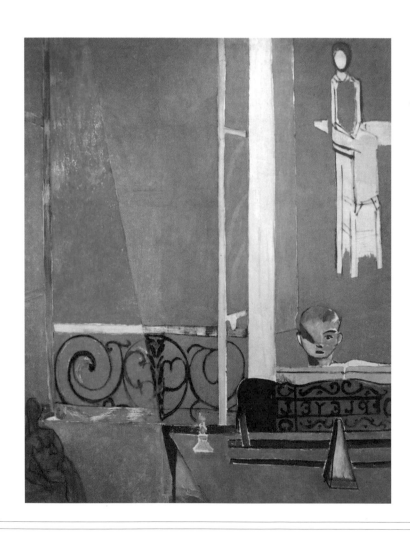

Let's Go!

Fig. 1

Fig. 2

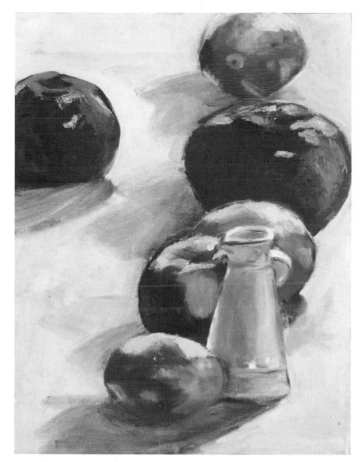

1. Create an eleven-step scale using only the green and red on either end. The challenge of this is to create even steps (fig. 1).

2. Now adding white to the red and green on your palette, try to mix a variety of colors from bright and dark to pale and muted (fig. 2).

3. Select a simple still life and begin painting. It is a good idea to put down a ground of color first, be it bright or muted, and then to build up from there instead of being intimidated by the white of the paper.

Above: Zimbiri Zimbiri, still life, oil on canvas

Opposite top left: Lindsey Gillis, *Red and Green Cat*, acrylic on paper

Opposite right: Henri Matisse, *The Piano Lesson*, oil on canvas, 1916

Take It Further

Try using variants of red such as alizarin, iron oxide, and quinacridone. Also try varieties of green such as viridian, cobalt teal, or sap. Mix it up!

Complementary Colors:
Blue and Orange

I must admit, this is my personal favorite of the complementary sets, and I use the combination often in my own work. This is probably due to my love of the color blue, and from this orange follows. I really just enjoy the psychological dynamism that occurs when these two colors come together. Vincent van Gogh's famous painting below is a beautiful example of this color set.

- ultramarine blue
 (acrylic or gouache)
- cadmium orange hue
 (acrylic or gouache)
- heavyweight drawing paper
- palette knife
- acrylic gel medium

"Instead of trying to reproduce exactly what I see before me, I make more arbitrary use of color to express myself more forcefully."

—Vincent van Gogh

Vincent van Gogh, *Starry Night*, oil on canvas, 1889

Let's Go!

Fig. 1

Fig. 2

1. Create an eleven-step scale with blue on one end and orange on the other (fig. 1). Make even steps!

2. Begin exploring the mixtures available from this palette (fig. 2).

3. Mask off a 10" × 10" (25.4 × 25.4 cm) square, select a simple still life, and begin painting.

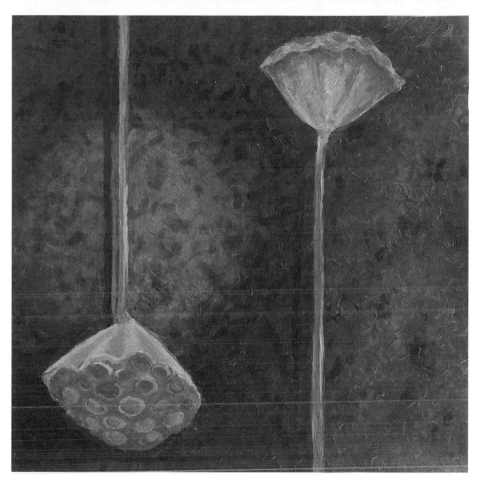

Leah Smith, lotus pod study, acrylic on paper

Tips

- Each complementary set contains a warm and a cool tone. When using these in a painting, the warm colors can be used for highlights, and the cool tones for shadow.

- This color combination is also very useful when painting skyscapes, because by just mixing a little orange into your blue you can create a vast symphony of tones, from wedgewood to gunmetal to steely blue-gray.

Complementary Colors:
Violet and Yellow

Materials

- cadmium yellow medium hue (acrylic or gouache)
- dioxazine violet (acrylic or gouache)
- titanium white (acrylic or gouache)
- heavyweight drawing paper to paint on and create scales
- palette knife

This set of complementary colors lends great luminosity to your painting because yellow is the most reflective color on the spectrum. Impressionist painter Claude Monet used violet and purple in his paintings over and over to achieve that dappled, hazy light that he is so famous for.

Claude Monet, *The Waterlily Pond with the Japanese Bridge*, oil on canvas, 1899

"There is nothing like looking, if you want to find something. You certainly usually find something, if you look, but it is not always quite the something you were after."

—J. R. R. Tolkien

Let's Go!

Fig. 1

Fig. 2

Tip

Limiting your palette to a set of complementary colors (plus white) is a great way to explore color. Because these colors are opposing forces chromatically, when mixed together, they yield a multitude of tones and hues, both strong and muted, which can bring great variety to your painting. And because you are mixing from such a limited set, you are guaranteed harmony in your color way.

1. Construct an eleven-step scale (11" × 1½" [27.9 × 3.8 cm]) that starts with yellow and, through additional incremental parts of violet, ends in violet. You should notice that the intensity collapses in the center as the two colors begin to neutralize, and then it emerges again as it reaches violet.

2. Now select a simple still life to paint onto a 10" × 10" (25.4 × 25.4 cm) square of heavyweight paper. Add the titanium white to your palette and try tinting the yellow/violet mixtures for soft and subtle hues (fig. 1). With your palette knife really explore the potential of your color range through mixing. Start painting (fig. 2).

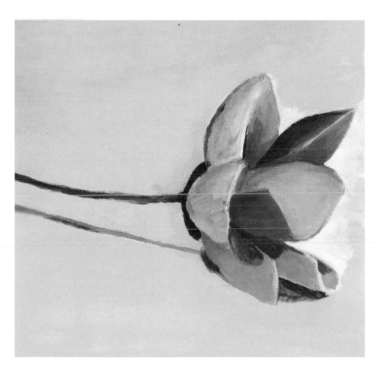

Kate Burleson, 2-D design study, acrylic on paper

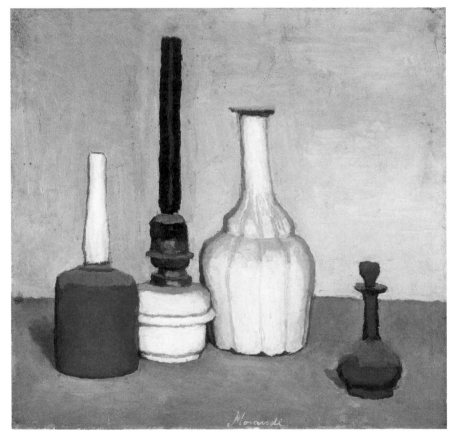

When mixing complementary colors we create tones called chromatic grays, which can create a subtle muted beauty and quieting effect in your painting. Chromatic grays bring pause, and caesura. This differs from the labs on complementary colors. You will be focusing on the middle chromatic-gray mixtures exclusively and mixing them with white.

- any set of complementary colors (red/green, yellow/ violet, blue/orange)
- white paint
- collection of simple forms from your home

"Out of clutter, find simplicity. From discord, find harmony. In the middle of difficulty lies opportunity."
—Albert Einstein

Giorgio Morandi, still life, 1941

Fig. 1

Fig. 2

1. Find neutral colored objects that interest you and arrange them on a white surface (fig. 1).

2. Select two complementary colors and mix these together to neutralize the color.

3. Take this mixture, and mix it with white to toggle up and down your value range in the painting (fig. 2).

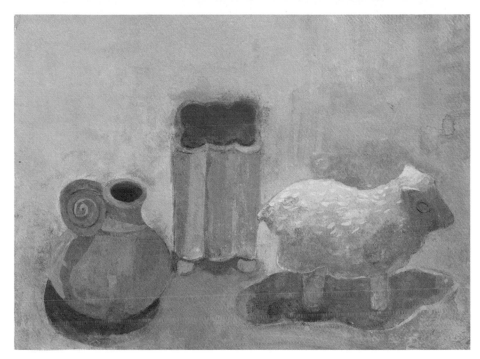

Momento, gouache on paper

Giorgio Morandi

The Italian artist Morandi was a master at utilizing chromatic grays to convey the quiet elegance of his domestic still lifes. Painting without recessive colors is like having a conversation while screaming the whole time.

Take It Further

This palette could be interesting to use in painting a landscape to create a quieted space. It could also be interesting to use these colors in Albers's *Homage to the Square*, "Lab 37," to create subtlety.

Glazing Veils of Color

- acrylic paint
- acrylic gloss medium or glazing medium
- white canvas or paper
- jars for storing mixtures

"If you always do what you always did—you always get what you always got."

—Unknown

Another way to mix colors is by building them with transparent veils of color called glazing. This creates a sense of luminosity and atmosphere in your painting. In this project we will thin down acrylic paints with medium, and then layer them repeatedly, allowing for a dynamic bounce of light as it travels through these many delicate tiers of color.

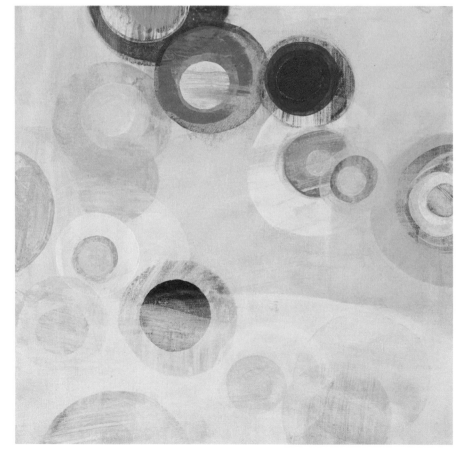

Warm as Yellow, acrylic on canvas

Fig. 1

Fig. 2

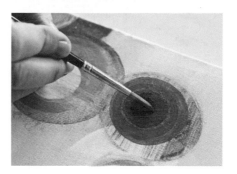

Fig. 4

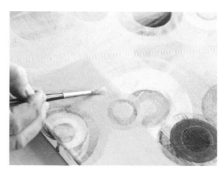

Fig. 3

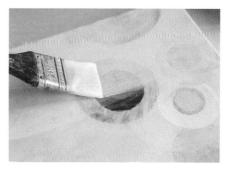

Fig. 5

1. Begin by selecting your color palette and create mixtures of these three or four colors in jars with a 1:3 ratio of paint to medium (figs. 1, 2). Please note that this ratio is subject to the inherent transparency or opacity of pigment. For example: Hansa yellow is transparent, and titanium white is opaque.

2. Making simple forms, experiment with layering and mixing your color with your colored glaze mixtures, letting each layer dry in between color applications (fig. 3).

3. Experiment with layering darkly pigmented glazes and lighter glazes to achieve an array of effects (figs. 4, 5).

Tip

Use a limited palette of three or four colors in this project so that you maintain a connectedness in the color relationships. Try to keep the focus on color experimentation by playing with basic forms.

Take It Further

This glazing technique can be applied to a variety of Labs such as the painting at the beach project, "Lab 35," or "Lab 1," with Klee mark making.

Colorful Cuts:
Complex Color Palette

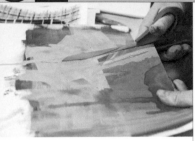

- watercolor paper sheets
- primary set of watercolor or gouache paints (plus white and black)
- acid-free glue
- waxed paper
- scissors

For this final project we will explore a primary palette and how to incorporate this with collage and experimental patterning to get a wide array of results. And of course with a primary palette there is a wide array of color available. There are just three ideas with the palette featured here, but the possibilities are endless.

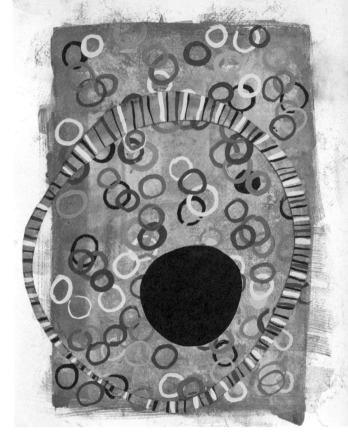

Hoops, collaged gouache on paper

"As practice makes perfect, I cannot but make progress; each drawing one makes, each study one paints, is a step forward."
—Vincent van Gogh

Let's Go!

Fig. 1

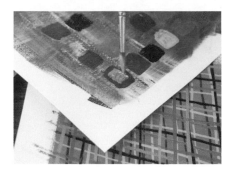

Fig. 2

1. Select your primary colors and begin mixing them. Have fun exploring the wide variety of colors available (fig. 1).

2. Now take those colors and spread out four or five pieces of watercolor paper on the table. See if you can apply the paint onto each sheet in different ways (wet on wet, patterns, etc.). Really have a sense of play in this step—let the colors guide you (fig. 2). You do not need to have an end result in mind here. Try to create variety!

3. Now start to cut up your different sheets to layer and create a new assembly of shapes, color, and texture interplay (figs. 3, 4). Use the glue to put these together. Flatten the finished pieces under heavy books with a layer of waxed paper on top of the painting to ensure good craftsmanship.

Fig. 3

Fig. 4

Tip

It is a common practice of artists to work in a series (with a chromatic structure that connects each piece) to really explore and unearth the potentiality of a technique and color way.

The colors I used were cadmium yellow deep, napthol red, and cobalt blue plus jet black and white. I tried to apply the colors differently onto each watercolor sheet in varying hues and textures to give myself a lot of options in the cutting collage process.

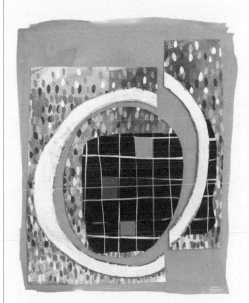

Big Orange, collage, gouache on paper

Recommended Books and Video

Albers, Josef. *The Interaction of Color*. New Haven, CT: Yale University Press, 2009.

Art:21 (TV series), PBS.

Bauhaus Archiv and Magdalena Droste. *Bauhaus 1919–1933 (Taschen 25)*. Cologne: Taschen, 2006.

Elkins, James. *What Painting Is*. London: Routledge, 2000.

Itten, Johannes. *Design and Form*, John Wiley & Sons, Inc., 1975

Itten, Johannes. *The Elements of Color*. New York: John Wiley & Sons, Inc., 1970.

Koren, Leonard. *Wabi-Sabi: for Artists, Designers, Poets & Philosophers*. Point Reyes, CA: Imperfect Publishing, 2008.

Contributors

Jennifer Bloom
www.hauteportraiture.net

Alyn Carlson
www.alyncarlson.com
colorgirlalyn.blogspot.com
www.flickr.com/photos/alynnie

Rebecca Jenness
www.rebeccaejenness.com

Keren Kroul
www.kerenkroul.com
kerenlk@hotmail.com

Michael Lazarus
www.michaellazarus.com

Thomas Sgouros
www.cadetompkins.com/artists/
thomas-sgouros

Faith Evans-Sills
www.faithevanssills.com

Patricia Stone
www.thepaintedway.com
pstone@wheatonma.edu

Neal T. Walsh
www.nealtwalsh.com
paintclot.blogspot.com

Additional Credits

Selin A. Ashaboglu
Kate Burlooon
Yitong Cai
Jaime A. Carvalho
Sandra Cordtz
Paris M. Dowd
India A. Dumont
Lindsey M. Gillis
Erin R. Girouard
Karina Holyoak Wood
Stephanie Hoomis
Alec J. Horwitz
Amy B. Magaletti
Sarah A. Redlich
Jennifer H. Sands
Leah S. Smith
Ava Wood
Maddy Wood
Zimbiri Zimbiri

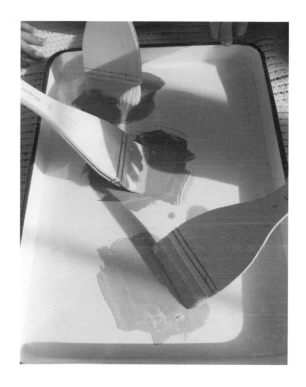

Photographer Credits

© Art Directors & TRIP / Alamy, 118 (right)

© The Artchives / Alamy, 36 (bottom, right)

The Bridgeman Art Library/Getty Images, 122 (right); 124

© B Christopher / Alamy, 114

De Agostini/Getty Images, 21 (bottom, right); 30; 126 (right)

© M. Flynn / Alamy, 82 (right)

Getty Images, 23 (bottom, right); 111

© Peter Horree / Alamy, 52 (top, left); 120 (right)

Marcia Patmos, 95

Photo Researchers/Getty Images, 34 (top, left)

© Photos 12 / Alamy, 26 (right)

Shutterstock.com, 14; 17

Time & Life Pictures/Getty Images, 19

© ZUMA Press, Inc. / Alamy, 32 (right); 71; 75 (bottom, right)

Courtesy of Private Collection Cade Tompkins Projects, 89; 96; 97

Suprematist Construction (oil on board), Malevich, Kazimir Severinovich (1878–1935) / State Russian
Museum, St. Petersburg, Russia / The Bridgeman Art Library, 28

Heroic Roses, 1938 (no 139) (oil on burlap), Klee, Paul (1879-1940) / Kunstsammlung
Nordrhein-Westfalen, Dusseldorf, Germany / The Bridgeman Art Library, 48, left

Acknowledgments

Thanks to the following:

To the late Joanne and Roy Forman for their unflappable love and support

To Mary Ann Hall for her patience and steady guidance

To Betsy Gammons for her clarity and judgment

To Chris Vaccaro for his artful eye

To my dynamic and talented friends

To my teachers who lit the way

To my students who inspire me

About the Author

Deborah Forman is a practicing artist and a passionate teacher of art with twenty years of experience instructing students from ages two to eighty. She is currently a visiting assistant professor at Wheaton College in Norton, Massachusetts, and an instructor in continuing education at the Rhode Island School of Design (RISD). Deborah specializes in teaching the fundamentals: drawing, two-dimensional design, color theory, beginning to advanced painting, and conceptual approach to painting and materials. In her own painting practice, Deborah works within the realm of geometric abstraction, with emphasis on the phenomena of color interaction.

Deborah earned her bachelor of fine arts degree in 1992 from Rhode Island School of Design. She went on to earn a master of science in art education in 1996 from the Massachusetts College of Art and Design, a school that believes teaching is an art form, with an emphasis on process over product and the importance of play and risk taking for artistic growth. Deborah has a master of fine arts in painting from the Parsons School of Design, where the focus of the program was contemporary art and theory, graduating in 2001.

Deborah has exhibited her paintings in Rhode Island as well as in various other venues throughout New England. She also provides a creative workshop series that can be used in a variety of settings. Visit her website at www.blueorangeworkshop.com.

© Chris Vaccaro